# MONET'S GARDENS

*Celebrated Subjects of the Great Artists*

❧ EDMUND SWINGLEHURST ❧

THEMES AND REFLECTIONS

# MONET'S GARDENS

*Celebrated Subjects of the Great Artists*

## ❧ EDMUND SWINGLEHURST ❧

SMITHMARK

Copyright © 1997 Parragon

This edition published in 1997 by SMITHMARK Publishers,
a division of U.S. Media Holdings Inc.
16 East 32nd Street, New York, NY 10016.

SMITHMARK books are available for bulk purchase for sales promotion and premium use.
For details write or call  the manager of special sales, SMITHMARK Publishers,
16 East 32nd Street, New York, NY 10016; (212) 532-6600.

Produced by Kingfisher Design, London
for
Parragon
Unit 13–17
Avonbridge Trading Estate
Atlantic Road
Avonmouth
Bristol BS11 9QD

ISBN: 0-7651-9823-1

Printed in Italy

10 9 8 7 6 5 4 3 2 1

**Acknowledgements**
*Series Art Director:* Pedro Prá-Lopez, Kingfisher Design, London
*Designers:* Frank Landamore, Frances Prá-Lopez, Kingfisher Design, London
*Editors:* Janice Anderson, Anne Crane

The publishers would like to thank Joanna Hartley at the
Bridgeman Art Library, London for her invaluable help

# CLAUDE MONET

## THE MUSIC OF COLOUR

CLAUDE MONET, who was born in Paris in 1840, all his life gained great satisfaction from painting gardens and flowers in nature, but satisfaction became an obsession after 1890, when he bought the property in the village of Giverny near the River Epte, a tributary of the Seine, which he had been leasing since 1883. This rural property, 30 kilometres (18 ½ miles) from Rouen, was to become Monet's microcosm of nature, a 'landscape' as he liked to call it, despite its size, which led him on to a total holistic view of nature and existence.

Unlike Cézanne, whose approach to painting was more like that of a reductionist scientist, finding truth by a splitting up of nature, Monet explored the more difficult and ambiguous route to visual truth by a metaphysical approach with all its ambiguities and uncertainties.

At the beginning of his career as a painter such an abstruse objective would never have occurred to him, for his sights were set on a nearer horizon as a successful cartoonist in Le Havre where he lived in his father's house in the seaside suburb of Sainte-Adresse. A meeting with a local artist, Eugène Boudin, in 1858 when Monet was 18, introduced him to the wider world of landscape painting in the open air.

Boudin was a modest and unassuming man who had a passion for painting local scenes direct from nature. His enthusiasm fired the young Monet's imagination and soon they were going out together to paint scenes around Le Havre and the little harbour of Honfleur to the west of the Seine estuary. Later, the painters were joined by a third artist, the Dutchman Johan Jongkind, who had a special talent for painting scenes with a great deal of sky and whose influence

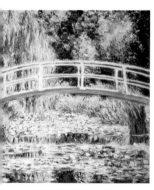

*White Nenuphars,*
1899

Detail from *Women in the Garden,* 1866

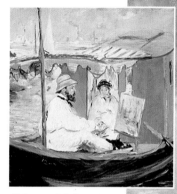

Edouard Manet:
*Monet Working on his Boat at Argenteuil,* 1874

on Monet was acknowledged later when the painter declared, 'He was my real master, to him I owe the education of my eye.'

The centre of the art world at this time was Paris, where acceptance at the Salon was essential for anyone wishing to make a living as an artist. Monet persuaded his father to allow him to go to Paris and even to provide an allowance so that he could study art there. On his first visit in 1859 he joined the Académie Suisse where he met Boudin's former teacher Gustave Troyon. His studies were interrupted when he was called up for military service in Algiers but on contracting an illness there he was repatriated and was able to continue his studies at Gleyre's studio in Paris.

Gleyre, though a traditionalist, allowed his students considerable freedom and Monet was happy there with such companions as Frédéric Bazille, Pierre Auguste Renoir and Alfred Sisley. He settled happily into the artistic milieu in which he also met Camille Pissarro, Edgar Degas and Edouard Manet. With such stimulating company, among the nucleus of the group of painters who were later to be known as Impressionists, Monet's ideas flourished.

Acceptance at the 1865 Salon for two of his Le Havre paintings, *The Point de la Hève* and *The Seine at Honfleur*, seemed to indicate that Monet's ideas were on the right lines. He was so encouraged that he began a giant canvas of a picnic scene, emulating Manet's *Le Déjeuner sur l'Herbe* which had been a *succès de scandale* at the 1863 Salon des Refusés. But Monet did not finish the work in time for submission to the 1866 Salon and only succeeded in annoying Manet, who accused him of plagiarism.

Determined to be in the 1866 Salon exhibition with something, Monet quickly painted a picture of his mistress, Camille Doncieux, which he called *Woman in a Green Dress*. This was accepted and was greatly praised. The following year, Monet tried again with a large canvas with an outdoor, garden theme which he called *Women in the Garden*, but this was refused and made Monet feel that he had to dedicate himself to his own vision.

Now began a creative but painful period in Monet's life. Rejected by the Salon again in 1869, Monet's earnings dwindled. Even so, he continued to explore new avenues in his art with the help of the ideas he discussed with his friends of the Gleyre studio. The excitement of feeling that they were on the threshold of a new kind of art spurred them all on in spite of the financial difficulties.

Monet devoted himself to small studies of light and colour along the Seine and the Normandy coast until he was driven into exile by the Franco-Prussian War of 1870. Taking the first boat to England to escape military service — leaving so quickly that Camille, now his wife, and their baby son had to follow on later — Monet went to London with his paint box.

In the English capital he found the weather atrocious and the smoky fogs obscured any view that might interest a painter. Making the best of a bad job, Monet began to paint scenes on the Thames which, with its shipping and constant movement, he perhaps felt as a link with Le Havre and France.

Now something new began to emerge on his canvases. Broad areas of diffuse colour in which detail disappeared or was only suggested took the place of the brightly lit and clearly defined plants and human figures of his paintings of the 1860s. He was discovering the way of painting which would bloom in his last years at Giverny on huge canvases of the pond and waterlilies which would become the microcosm of the whole world of nature.

On his return to France after the war, Monet settled in Argenteuil on the Seine to the north of Paris, a place which was popular with the new French bourgeoisie for boating and sailing. Here Monet forgot the mists of London and devoted himself to bright, colourful paintings of the river. It was a happy time for him for his wife and child were with him and his home became a meeting place for friends who included his companions of the Gleyre studio and Paul Cézanne who, like him, was discovering that colour alone could be used to create a picture.

It was out of these meetings at Argenteuil and at cafés like the Café Guerbois in Paris that Impressionism, with Monet as one of its leading artists, was born.

Not that Monet and his friends called themselves Impressionists. In April 1874, their meetings and discussions bore fruit in the form of an exhibition in Paris of the work of a group of 'independent artists' which included Monet, Renoir, Sisley, Cézanne, Pissarro, Morisot and Boudin. Monet called a painting of Le Havre he exhibited *Impression: Sunrise*, and the word 'impressionist' was coined by a critic as a term of abuse to attack what he saw, and did not admire, at the exhibition. The exhibition was not a financial success, but the artists who had exhibited at it were at least names to be conjured with in the world of art.

Although still poor for most of the 1870s, Monet survived with occasional sales to friends and, in particular, to a businessman called Ernest Hoschedé, at whose château at Montgeron the Monet family stayed in the summer of 1876. The happy relationship with the Hoschedé family was short-lived, for Ernest Hoschedé's business began to fail. He left for Paris to rescue what he could while his wife, Alice, and their children stayed with the Monets.

Eventually the Hoschedé and Monet families moved to another Hoschedé house at Vétheuil, where they were to remain until 1881, despite the tragically early death of Camille Monet in 1879. Though his circumstances were still precarious Monet enjoyed his enlarged family and recorded their walks through fields full of wild flowers and poppies.

A social revolution was taking place in post-Imperial France, with an increasingly well-off middle class wishing to show their newly achieved social status by buying such luxuries as paintings. It was a demand that Monet was eager and ready to supply. Through his friend the picture dealer Paul Durand-Ruel, whom he had become acquainted with at the gallery in London the dealer had started during his exile, Monet began to sell a steady trickle of paintings.

Subject matter was important to the art buyers and Monet now began to travel more widely, painting scenes of popular holiday places, among them Trouville and Etretat in Normandy, Belle Ile on the Atlantic coast of France, and, later, the French Riviera and Bordighera on the Italian Riviera.

Constantly away, Monet began a long and revealing correspondence with Alice Hoschedé in which he recounted his adventures, such as when he was nearly swept out to sea at Etretat and the difficulties of painting in stormy weather at Belle Ile. The Hoschedé and Monet joint household moved to Poissy in 1881, and then to Giverny, where Monet leased a farmhouse, in 1883. By now, Alice Hoschedé was in charge of the Monet household, though they observed the social niceties by addressing each other as Monsieur Monet and Madame Hoschedé in public. They married in 1892, after Ernest Hoschedé's death.

Both in London and, later, in Paris, Monet had tackled series of paintings, one of the Thames and one of the Gare St Lazare railway station in Paris, in each case making the handling of the paint more important than the detail of the subject. Now at Giverny, which Monet bought in 1890, he found other subjects for series of paintings in which he could develop further his studies of colour.

One of these was a line of poplars along the River Epte and another was a field of haystacks. Neither was particularly exciting as a subject in its own right but they were ideal as objects on which to observe the light and atmosphere at different times of day and in different kinds of weather.

It was about this time that Monet awoke to the potential of his own garden, which had originally been full of vegetables but in which he had been planting more and more flowers. In 1893 he extended his domain by buying a piece of marshland near the river, separated from the Giverny house and garden by a road and a railway line. He was enthusiastic about turning this land into a water garden, with a pond, which he began digging out in 1894. Later, he bought more land in order to enlarge the pond and to draw water from the Epte in an orderly manner through sluices which would control the flow. There were protests from local people but Monet pressed on, carefully planning his gardens, buying suitable plants and clearing the pond bottom.

By the turn of the century, having made one last foray into Rouen to paint a

great series of paintings of Rouen cathedral in all weathers and all lights, Monet needed no other landscape than the one he had created at Giverny. He now had complementary gardens: a Western-style flower garden round the house and an Oriental-style water garden across the road.

He built a Japanese-style bridge over the pond in the water garden and planted trees, including poplars, ash, beech, maple, tamarind, Japanese cherry and willows along its edge. He took on gardeners to help him in both the garden round the house and the water garden, putting in tulips and forget-me-nots for the spring, pansies and hollyhocks, asters, hydrangeas, poppies and irises for summer and autumn. His idea was to have lots of the common or ordinary garden flowers, especially the tall varieties, and not those specially bred by horticulturalists, blooming throughout the year. In his pond in the water garden he planted waterlilies.

While Monet made painting trips to Normandy, Norway, England and Venice in the 1890s and the first decade of the twentieth century, he also began painting his garden on a grand scale. His first exhibition of waterlily paintings took place in Paris in 1900, his sixtieth year. As the twentieth century progressed Monet developed an ambition to paint a gigantic series of paintings of his waterlily pond. The paintings would be vast — up to 2 metres (6 feet 6 inches) high by 6 metres (19 feet 6 inches) or more long — and would fill a room so that the spectator would be completely surrounded by them.

Monet's early paintings of his pond showed it very much as it was, with trees, paths and borders around it and the sky above. Gradually, he eliminated everything except the water and its reflections and the waterlilies on the surface. In 1916 he even built a special studio in the garden at Giverny to house the canvases and had moveable easels made to enable him to work on different canvases. He had always worked on several canvases at once and he continued to do so, to the amazement of the Gimpels, art dealers who reckoned they had seen thirty canvases in this amazing world of Monet's creation.

Then a dark cloud appeared in Monet's otherwise optimistic sky. He was having trouble with his sight, which became greatly impaired because of cataracts, and began to doubt whether he could complete his project. At this point a guardian angel appeared in the form of Georges Clemenceau, a politician who was destined to lead France from 1917 until peace was established. Monet, living with his stepdaughters in his quietly ordered world since the death of his wife Alice in 1911, had managed to avoid thinking about the war except to say he was not moving and if the savages wanted to kill him they would have to do it in his studio surrounded by his work.

His real enemy, however, was his sight, which he refused to have anything done about for fear that he would lose what sight he had. He wrote to his friends to say he was finished, that the work would never be completed. But Clemenceau, who was not called 'Tiger' for nothing, insisted. Monet would finish the work which would become one of the glories of France. What is more, Monet would have his sight seen to.

In the end Monet gave in and saw a Dr Coutela who gave him eye drops and special spectacles. Monet laboured on, seldom taking time off, though he did attend the funeral of Edgar Degas in Paris in 1917. By the time the war ended the great project was almost complete but Monet's sight was nearly gone. In 1923 he had an operation to remove a double cataract. At first, it seemed to do little good and then, suddenly, Monet wrote to Dr Coutela to say that his sight was fully restored again.

This was a little more than a year before he died and his paintings of the time show a confusion of colour which is almost abstract in concept. Was this where Monet was really heading? Was he in his final years the advance guard of Abstract Impressionism, a kind of Jackson Pollock? Nobody knows, for Monet no longer wrote about his ideas. Though he liked to see his friends, he had become a kind of hermit buried in his world of colour sensation which would envelop its viewers as if they were in a cathedral and induce them to meditate about life.

On his death in December 1926 Claude Monet was buried at Giverny alongside his wife Alice Hoschedé. The tomb is simple, with a sheaf of wheat as a headstone to symbolize his love of nature and the earth. After the death of Blanche Hoschedé-Monet, Monet's stepdaughter and daughter-in-law, in 1947, the house and garden, which had been damaged during the Second World War, fell into neglect. In 1966 the estate was given to the nation by Monet's son Michel Monet and was restored as a shrine which gives pleasure to millions of people from all over the world — as do the waterlily paintings which, thanks to Georges Clemenceau, found a worthy permanent home in specially built galleries at the Musée de l'Orangerie in Paris.

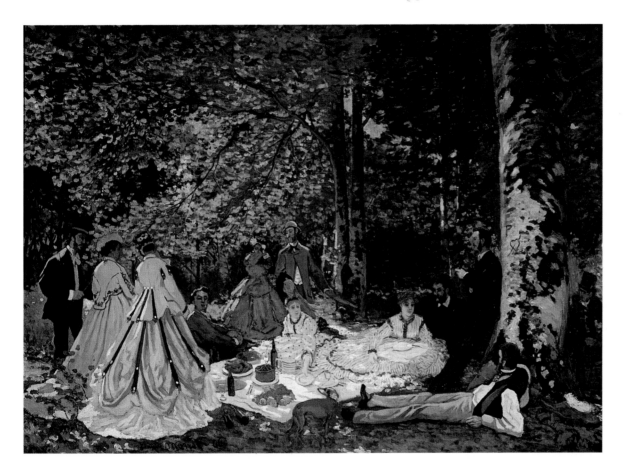

## LE DÉJEUNER SUR L'HERBE

*1866  Oil on canvas*

The aim of all artists in France in the mid-nineteenth century was to be accepted by the annual Salon in Paris which would bring their work to public attention. Preference was given to paintings in the traditional style but Manet's *succès de scandale* at the 1863 Salon des Refusés with his *Déjeuner sur l'Herbe* encouraged Monet also to do a large painting of people at a picnic, with the aim of having it accepted for the Salon of 1866. He was too ambitious, however, and the painting was not finished in time. *The Picnic* was Monet's original oil sketch for the larger work.

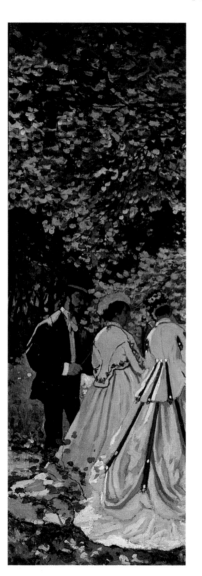

## DÉJEUNER SUR L'HERBE, CHAILLY (Left panel)

*1865-6  Oil*

Nearly twenty years after he painted it, Monet's ambitiously large painting, *Le Déjeuner sur l'Herbe*, which had been badly stored, had to be cut into three sections. This is the left section, corresponding to the left-hand side of *The Picnic* (page 13). The changes Monet made to his original sketch are clear. The figures are stronger and more colourful. There is a marked open air feeling, with strong sunlight coming through the leaves and the contrasting background throwing into relief the patches of sun. This was something new at a time when most painters worked indoors in studios and produced paintings which were often dark brown in tone. The subject, men and women enjoying an informal picnic, was also new.

## DÉJEUNER SUR L'HERBE, CHAILLY (Central panel)

*1865-6  Oil on canvas*

Judging by this section of *Le Déjeuner sur l'Herbe,* Monet had some major second thoughts about the composition after he sketched *The Picnic.* It would seem that he found the centre too crowded and eliminated the figure of the man lying in the foreground as well as several background figures, replacing them with one seated man. He also cleared the objects on the tablecloth to the right and straightened the woman's arm, thus creating a vertical line to take the eye to the background couple and thus into the rest of the painting.

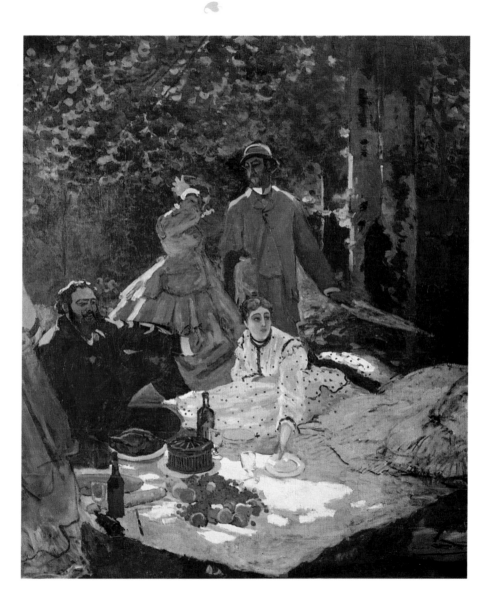

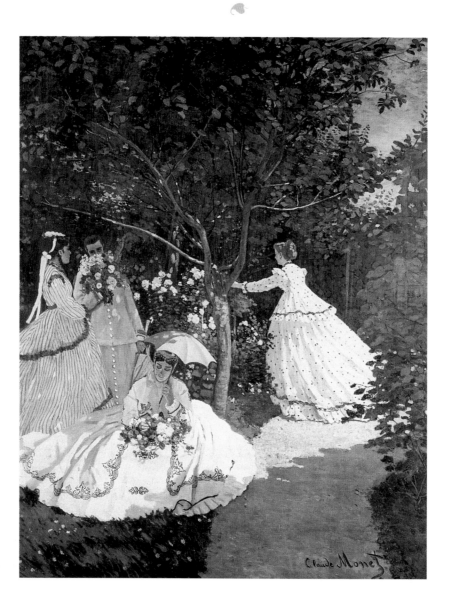

## WOMEN IN THE GARDEN

*1867 Oil on canvas*

The idea of a large painting showing figures in the open air persisted in Monet's mind and he tried other garden scenes in full sunlight. All the figures in this large canvas, which measured 2.55 x 2.05 metres, were posed for by his mistress, Camille Doncieux, who became his wife in 1870. The size of the painting obliged Monet to dig a trench in the garden of his house at Sèvres, near Paris, so that he could reach the upper section of the canvas comfortably. This painting was finished in time for submission to the Salon of 1867, but was refused.

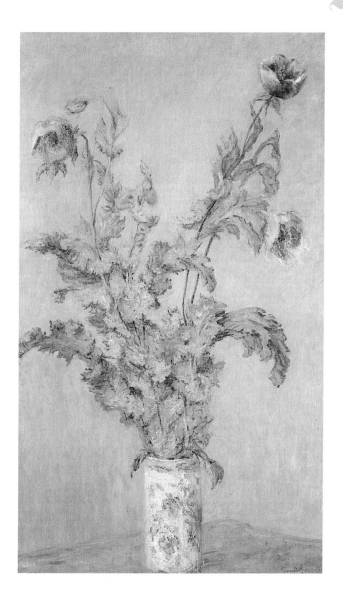

## PURPLE POPPIES

*1866  Oil*

Claude Monet's first attempts at painting flowers in detail were painstakingly correct in an academic way and gave very little indication of the eye for colour that he would develop later and which would make him the leader of the Impressionist movement. At the time that he painted this picture he was more interested in painting in the open air, partly as a result of painting seascapes near his home at Le Havre, where he often worked alongside his friend Eugène Boudin. Later, Monet painted wild flowers and filled his garden at Giverny with them; he did not show much indication of ever being really inspired by cut flowers.

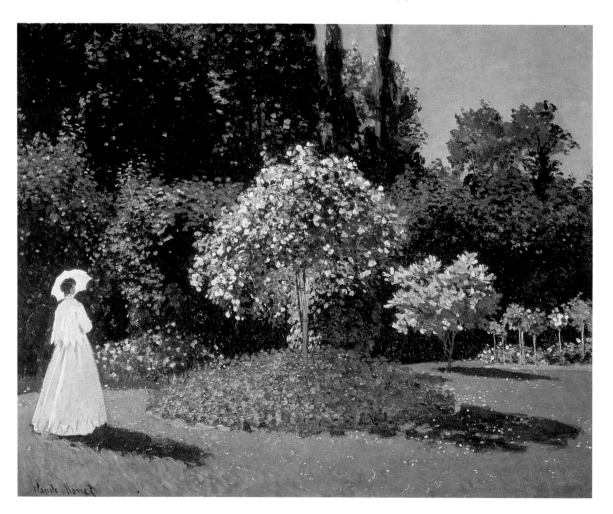

## LADY IN THE GARDEN

*c.1867  Oil on canvas*

This is another painting done during the period when Monet was experimenting with outdoor scenes in brilliant sunshine. At this time, before there had been a full working out of 'Impressionist' ideas about producing a natural effect of sunshine and colour by skilful use of primary and complementary colours, Monet was using strong contrasts to gain the effect he wanted. This can been seen here in the flowers and the woman's dress, set against a dark background. Once again, Monet's model here was the patient Camille who posed for him during the early, poverty-stricken years of their relationship.

## FLOWERING GARDEN AT SAINT-ADRESSE

*c.1866 Oil on canvas*

In this, as in other paintings by Monet from this period, there is too much tonal violence and the reds and pinks of the flowers are isolated from the rest of the painting. Monet's reaction to a bright sunny day has the exuberance of youth, however, and also indicates, in the way the flowers are painted, a certain youthful arrogance and optimism that reveals something of his character. Although he was going through a time of financial hardship, this never showed in his paintings, which were always full of *joie de vivre*.

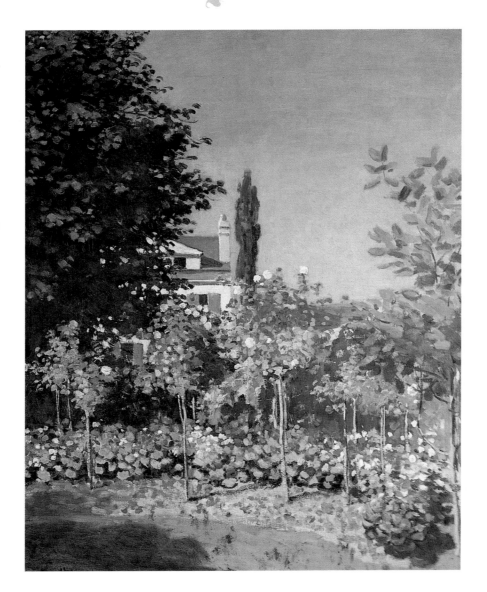

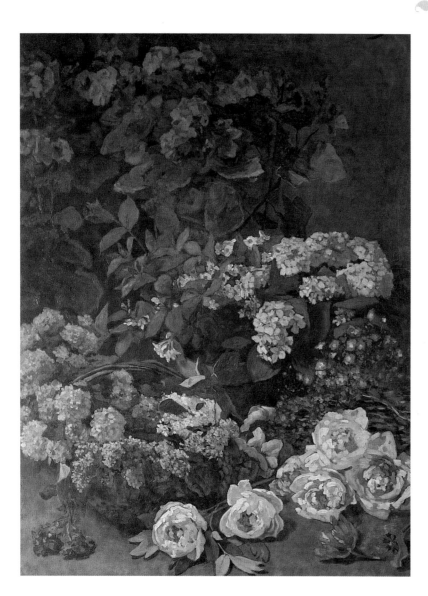

## SPRING FLOWERS

*1864 Oil on canvas*

Although Monet was devoted to the idea of painting in the open air, often doing so in the most appalling weather conditions, there were times when he was forced to stay indoors and paint still life subjects such as vases of cut flowers. In this study of roses and hydrangeas there is perhaps too much emphasis on the drawing and the colour does not achieve its full richness. Being a man with a lusty appetite for the good things of life, including fine food and drink, cut flowers must have seemed like tinned food.

## THE TERRACE AT SAINTE-ADRESSE

*1866 Oil on canvas*

Monet's father, who ran a grocery business, moved from Paris to Le Havre when Monet was a young boy. Their house at Le Havre looked out over the estuary of the Seine and must have seemed an exciting place to the young boy for the shipping lanes there and along the Channel were always busy. Monet's love of the sea, which was evident in his paintings until the love of his garden took over, grew out of his youth in Le Havre. In this wonderfully sunny picture, full of summer sea breezes, Monet combines both his great loves, the sea and flowers. The picture was painted during a particularly productive stay at Le Havre during the summer of 1867, which saw the birth, in August, of his and Camille's first son, Jean.

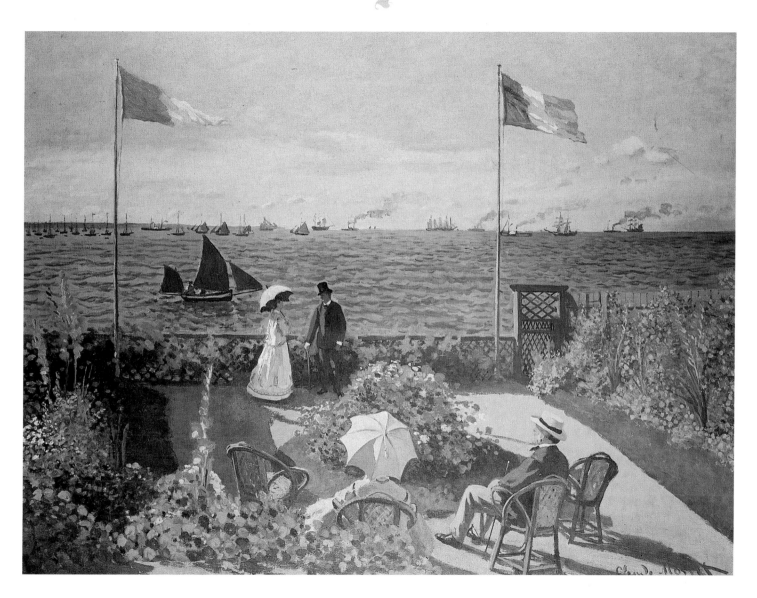

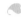

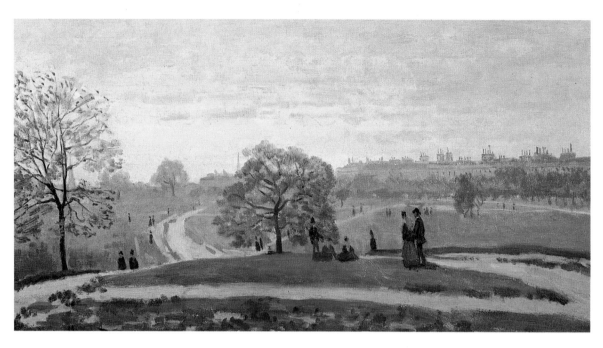

## HYDE PARK

*c.1870  Oil on canvas*

Most of Monet's paintings of London are studies of the River Thames, especially the Embankment and the Houses of Parliament, which makes this picture of Hyde Park a little unusual, although London's leafy parks were one of the aspects of the city he enjoyed greatly. It is interesting to note that he has somewhat exaggerated the rise and fall of the land, turning the park into a country scene, perhaps as a nostalgic reminder of the valley of the Seine which he had left on the outbreak of the Franco-Prussian war in 1870. With another French exile in London, Camille Pissarro, Monet often visited the National Gallery, where they discovered the work of J. M. W. Turner, whose paintings in the gallery included many studies of London's open spaces, though Monet was not inspired to imitate them.

## TULIP FIELDS WITH THE RIJNSBURG WINDMILL

*1872  Oil on canvas*

From England, Monet moved to Zaandam in Holland, rather than return direct to France, where his father had died, but where the Commune disturbances still raged. In the Netherlands the canals and windmills provided a new subject for Monet, besides reminding him of his friend from Le Havre days, the Dutch artist Jongkind. In his search for ways of painting light and air Monet found much inspiration in the reflections from the water and the vast open skies of Holland which, along with his studies of Japanese art, newly fashionable in Europe, opened new avenues of development for his paintings.

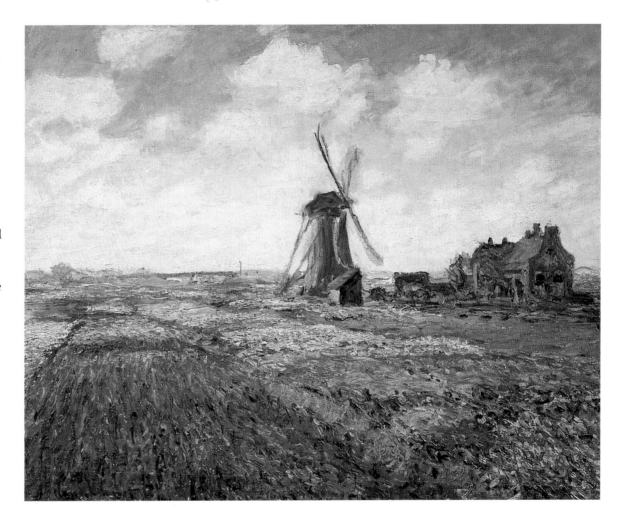

## THE LUNCHEON: MONET'S GARDEN AT ARGENTEUIL

*c.1873 Oil on canvas*

This idyllic scene reflects three essentials in Monet's life: family, flowers and food. The large painting — it measures 162 x 203 cm (65 x 81 inches) — was done in the summer of 1873 after Monet had come back from England and Holland when peace had returned to France. The child is his son Jean and the graceful woman in white his wife, Camille. The painting has links with Monet's earlier garden paintings, but his technique is now much more confident, even though he is still using contrasts of tone to express light and shade. The painting was included in the second Impressionist exhibition, held in Paris in 1876.

## WILD POPPIES, NEAR ARGENTEUIL

*1873 Oil on canvas*

Returning to the Ile de France in 1871, Monet took a house at Argenteuil on the Seine just to the north of Paris. It was here that Seurat was later to paint *La Grande Jatte*. It was a pretty place much favoured for boating and sailing and with plenty of open countryside with fields full of wild flowers, especially poppies. Here Monet, though poor, was able to entertain his artist friends, including Manet, Sisley, Degas, Renoir and others and to discuss with them the new ideas on colour. In this painting, done in the country near Monet's home at Argenteuil, the influence of Japanese art, with its spacious compositions, is evident.

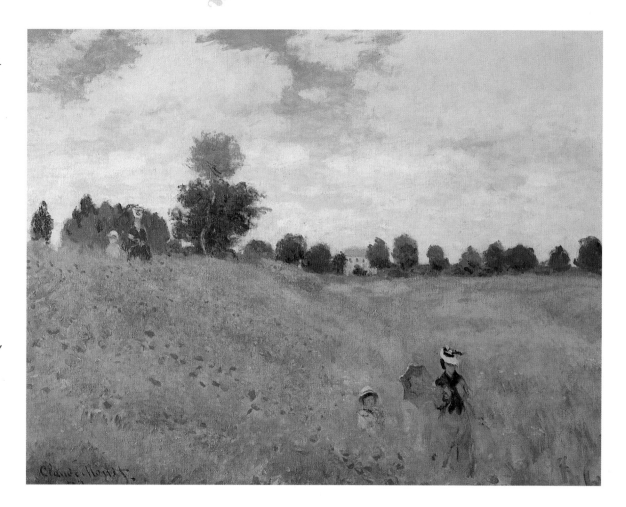

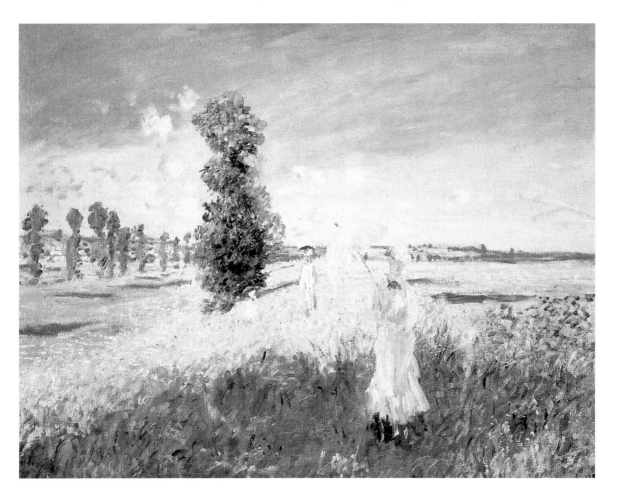

## THE WALK (ARGENTEUIL)

*c.1872-75  Oil on canvas*

At Argenteuil Monet's ideas on colour developed partly as a result of conversations with his fellow Impressionists and partly simply through looking at the countryside that he walked through with Camille and their son. He was no longer trying to reproduce the effect of sunlight by using strong contrast but instead was applying the new ideas on primary and complementary colours. Shadows ceased to be dark areas and became full brush strokes of blue, green and violet, quickly applied with a great spontaneity.

## A CORNER OF THE GARDEN AT MONTGERON

*1876-7  Oil on canvas*

Monet's friend Ernest Hoschedé was a successful businessman who helped to support the painter by buying his work and even invited him to stay at his château at Montgeron with his wife, Alice, and their family. Here Monet continued to work well, producing many fine studies of the garden, even though his financial situation was still precarious. Monet appreciated the garden and the many outings with his own and the Hoschedé children.

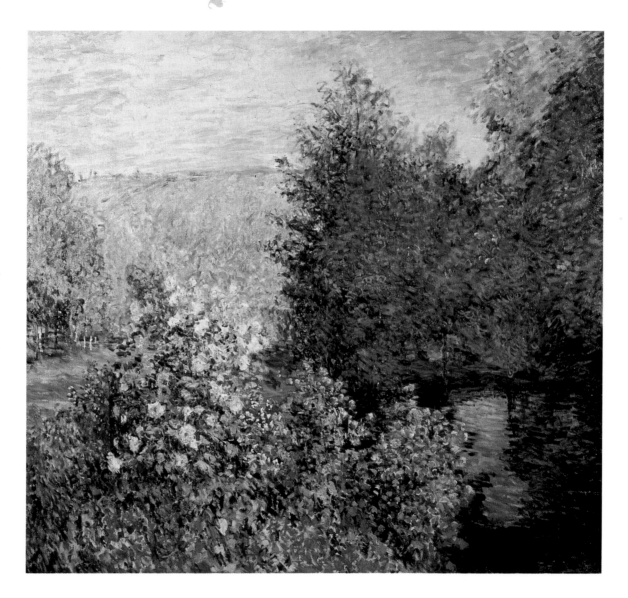

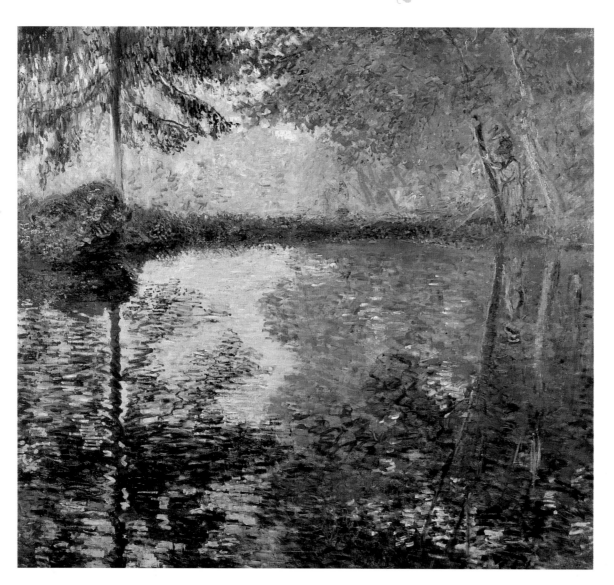

## THE LAKE AT MONTGERON

*1877  Oil on canvas*

The lake at the Hoschedés' Château de Rottenbourg at Montgeron pleased Monet who was stimulated by scenes with water. In this painting Monet moved away from careful definition of the shapes of the forms in the composition and concentrated on defining the form through colour alone, though he kept the foreground of tree trunks as a frame for the atmospheric scene beyond rather in the way he had used London's bridges in his paintings of the Thames.

## CHRYSANTHEMUMS

*1878 Oil on canvas*

The mid-1870s was a wonderfully fertile period for Monet, who began selling work regularly from this time. The Monet family also began living well, so that Monet was always short of cash, his penurious state driving him to paint any subject which he thought might have public appeal. Among favourite themes were pictures of the river and of sailing boats, a pastime enjoyed by the new bourgeoisie, gardens, snow scenes, views of the riverside villages, and the traditional still lifes which everyone liked. This still life of a bowl of chrysanthemums set against a flowered wallpaper was painted at Vétheuil at the house shared by the Monet and Hoschedé families.

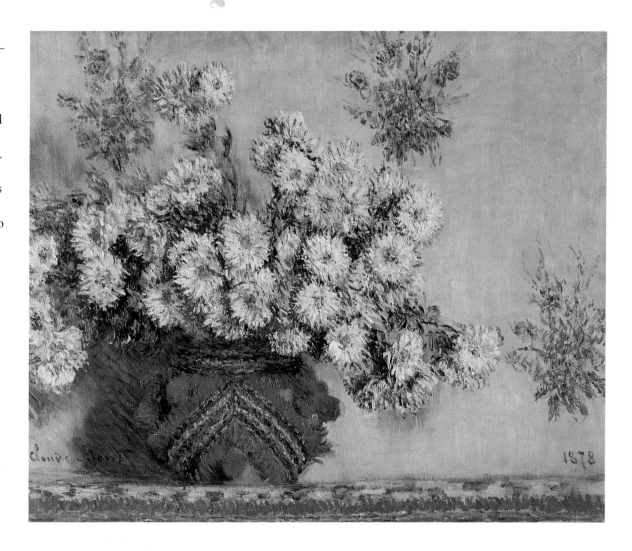

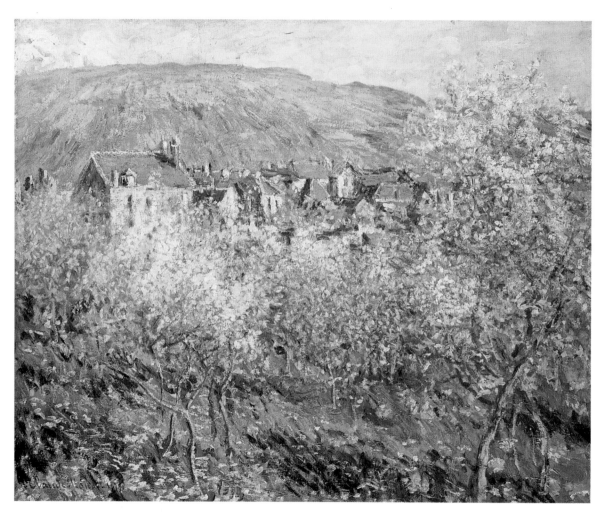

## APPLE TREES IN BLOSSOM

*1879  Oil on canvas*

This warm and lively picture of apple trees in blossom was a prelude to the orchard scenes which were to be a feature of Monet's work when he moved to Giverny in 1883. The year this picture was painted was a year of misfortune; Monet's wife, Camille, died and his patron Ernest Hoschedé went bankrupt. In the long run, none of this seems to have affected Monet, who was totally absorbed in his work, despite the financial failure of the Impressionist exhibitions in Paris.

## THE ARTIST'S GARDEN AT VÉTHEUIL

*1880 Oil on canvas*

Monet and his family moved to Vétheuil on the Seine in 1878, shortly after the birth of their second son, Michel. At Vétheuil they shared a large house with the Hoschedé family. This was the first time that Monet had lived for any length of time in a house with a large garden. He liked the way in which the plants grew wild, unlike most French gardens which had a formal design with flower-beds laid out neatly and surrounded with clipped border plants. The profusion of sunflowers, lilies and pansies in this picture, which includes several of the children of the combined families, reveals his love of untrammelled nature and the exuberance of plant life growing without too much interference from man.

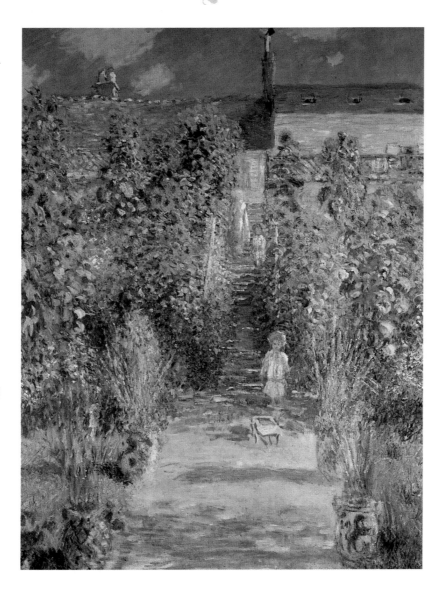

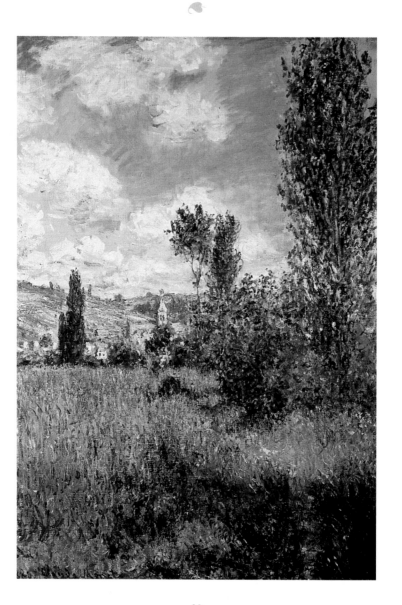

## PATH THROUGH THE POPPIES, ILE SAINT-MARTIN, VÉTHEUIL

*1880 Oil on canvas*

Though he was content to be living at Vétheuil, despite the tragically early death of his wife Camille in 1879, Monet was still concerned at not making enough money to maintain his family and spent much time painting pictures that might have a general appeal, though without compromising his artistic aims. Among these pictures were idyllic country scenes like this one of the country near Vétheuil. About this time Monet also began to travel to places that were becoming popular with the new middle class who could afford to travel and painted scenes in Normandy, on the Atlantic coast and in the South of France and Italy.

## GARDEN AT VÉTHEUIL

*1881 Oil on canvas*

Monet has signed and dated this picture of the garden at Vétheuil a year later than the one on page 31, but it is, in fact, another version of the original, though without the children. Monet painted four versions of the subject, perhaps to meet increased demand for his pictures. Vétheuil suited Monet because it was on the Seine and near enough to Paris to enable him to see the dealers on whom he depended for the sale of his paintings. In 1880 the magazine La Vie Moderne had organized a one-man show of his work and in 1881 his dealer friend Durand-Ruel also began dealing again in his paintings.

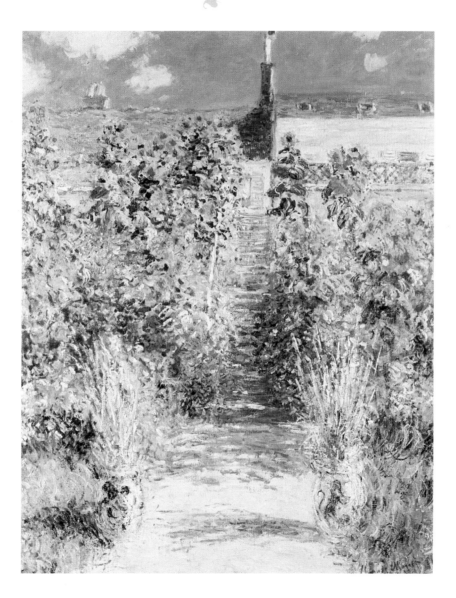

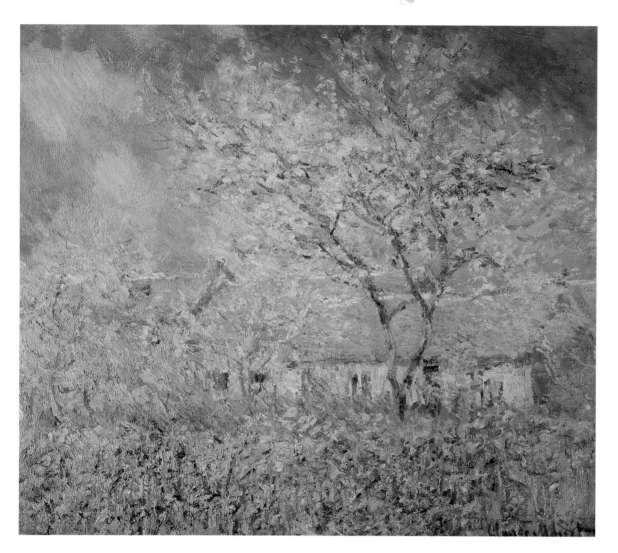

## SPRINGTIME AT GIVERNY

*c.1880  Oil on canvas*

In his excursions through the Normandy countryside Monet had found a place to which he was instantly attracted. It was a small village called Giverny. He moved there in 1883, into a house he rented by the River Epte, a tributary of the Seine, with his own and Alice Hoschedé's family. The garden around the house was devoted mostly to vegetables at this time and at first Monet saw it as just part of his home life; later it would become the main focus of his work as an artist. His pleasure in Giverny is very evident in this springtime painting with its free and lively brushwork.

## SPRING

*1880-82  Oil on canvas*

The fresh spring vegetation in the countryside bordering the Seine inspired this joyful picture, which shows Monet at the height of his powers, using confident brush strokes which give life and equilibrium to the scene. This picture is typical of what Impressionism achieved in the art of Monet and Sisley.

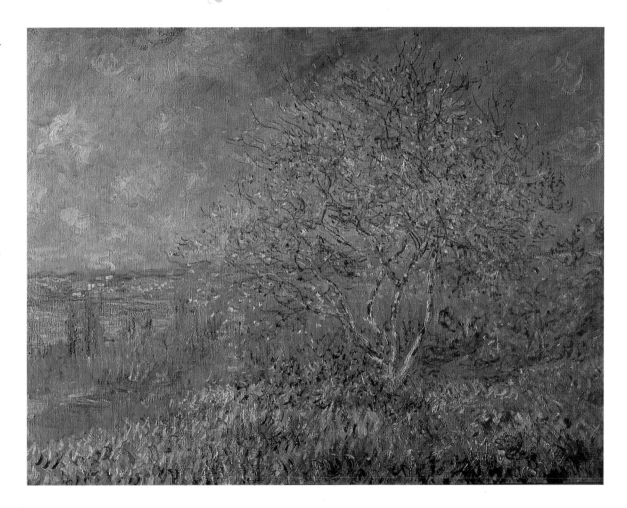

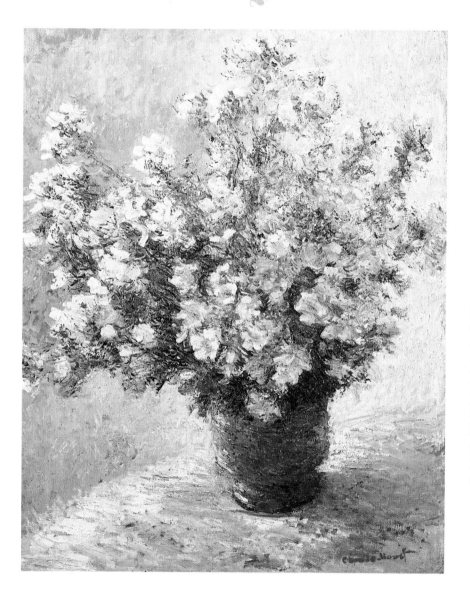

## VASE OF FLOWERS

*c.1881-2  Oil on canvas*

Still lifes of flowers are often used by artists as exercises to help them sort out problems in painting without the distractions of subjects in the outside world. In order to help him improve his use of colour, van Gogh painted more than 40 flowerpieces in one summer in Paris, while Cézanne found that a still life could be a captive subject, protected from the transitory effects of light and weather and thus allowing the painter to concentrate on his canvas. Moreover, a still life or flower painting is a marketable subject. In this painting Monet has used an Impressionist technique with which he and his public were already familiar and which they liked.

## BORDIGHERA

*1884  Oil on canvas*

Monet made his first visit to the Mediterranean at the end of 1883, a few months after he had moved his family to Giverny. In December he travelled on the Riviera coast with Renoir, his closest friend among the Impressionists, and spent the first four months of 1885 in Bordighera on the Italian Riviera. A motive for his trip could have been the thought of selling paintings of the Rivieras to the increasing numbers of people coming to these popular holiday coasts. Monet was astounded by the brilliance of the light and, though he was afraid that he could not cope with such strong colours, he painted some superb landscapes on the Mediterranean.

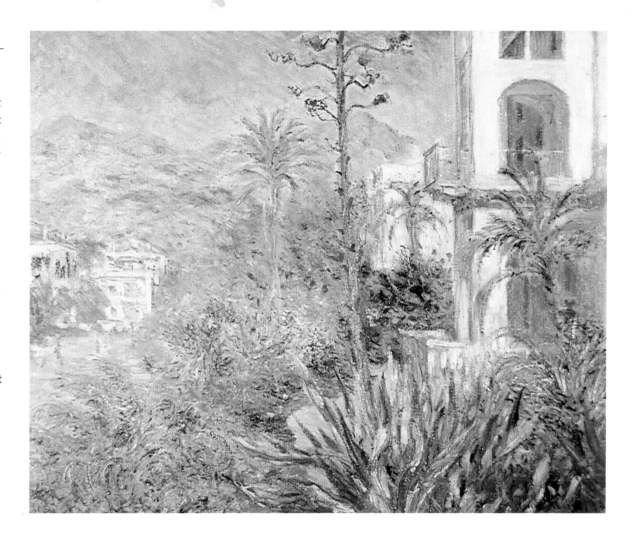

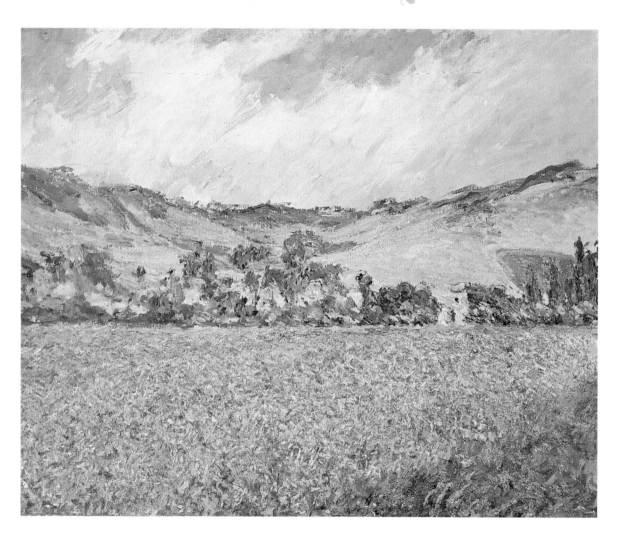

### THE POPPY FIELD NEAR GIVERNY

*1885  Oil on canvas*

The poppies in the valleys of tributaries of the Seine gladdened Monet's eyes and provided colourful subjects in that corner of France which was deep in his soul. The drama of the Atlantic and the brilliance of the south of France had excited him but what he most enjoyed was the cool, tranquil countryside of northern France in which he could ponder the mystery of the subtle colours of changing light and weather and their transformation of landscape.

## POPPY FIELD NEAR GIVERNY

*1885  Oil on canvas*

The joy of the Giverny countryside was that it was familiar territory, even down to the poppy fields that had first attracted Monet at Argenteuil. He found wild flowers more attractive than carefully nurtured garden plants and began to clear his own garden of its vegetables in order to encourage natural vegetation and to plant flowers that would grow profusely without special cultivation. In this happy environment he began to concentrate more and more on painting his own garden.

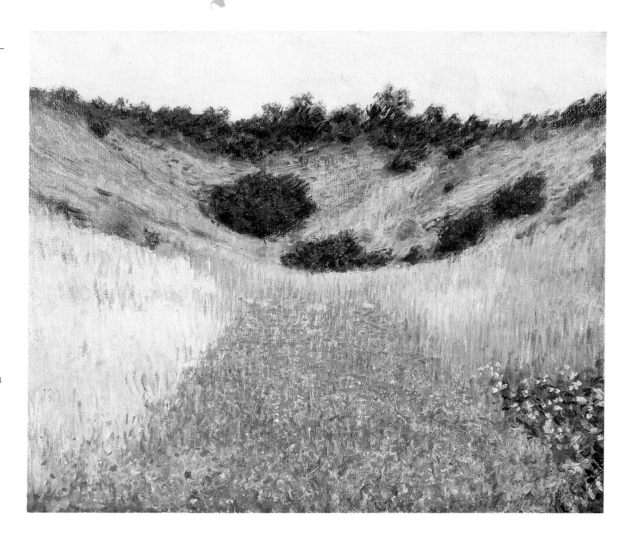

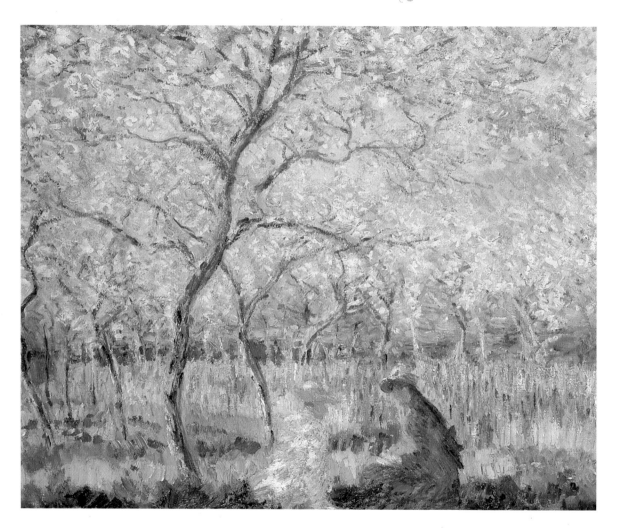

## SPRING

*1886  Oil on canvas*

The moods of Monet's paintings are many and varied, reflecting his own feelings of happiness, melancholy or spirituality at the time he was painting them. By some strange magic common to all great paintings, Monet's canvases project his personal feelings into the spirit of the viewer. This painting of spring, done in an orchard near Giverny, has the quality of uplifting the spirit with its fresh, virginal light and the touching poignancy of the delicate blossom, so pure and so ephemeral.

## WHITE NENUPHARS

*1899 Oil on canvas*

The modest, wood Japanese-style bridge which Monet had built over his pond at Giverny has become as famous as any of the world's great bridges. Its curve sets off the horizontal lines of the pond and the verticals of the trees. When Monet first bought land by a stream below his house in 1893, he was thinking only of the gardening possibilities, especially the idea of a picturesque water garden, which he began digging out in 1894. By the time he came to paint this picture he had had the 'revelation of the magic of my pond', as he recalled later. His pond and his waterlilies would soon dominate his work.

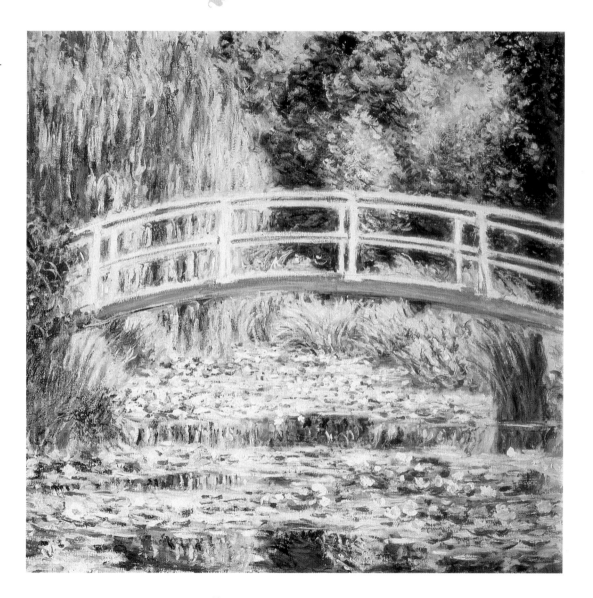

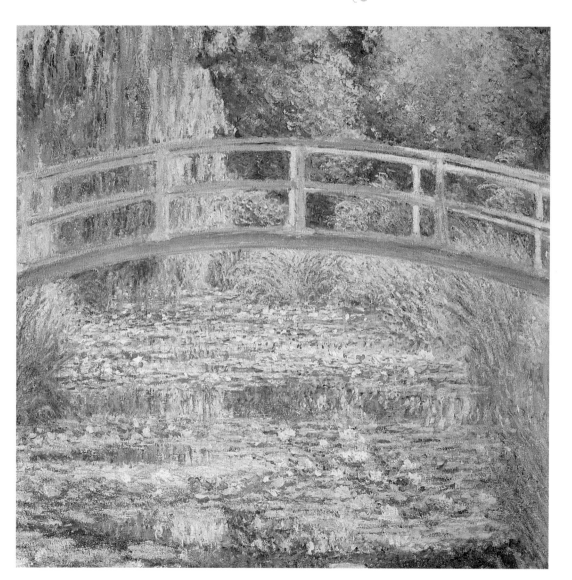

## WATERLILY POND

*1899 Oil on canvas*

Monet's enthusiasm for the bridge over his pond drove him to make many paintings of it at various times of day. The bridge, which later had wisteria growing over it, started as a simple unadorned structure of the kind that Monet had seen in many Japanese prints which had begun to reach Europe in the latter part of the 19th century. His own bridge was copied from a Japanese print that had hung in his dining room for some time. This painting, now in the National Gallery in London, was among the dozen pictures included in the first public exhibition of Monet's waterlily paintings, organized by the dealer Durand-Ruel and held in Paris in 1900.

## THE WATERLILY POND:
## GREEN HARMONY

*1899 Oil on canvas*

This painting of his waterlily pond in a cold morning light was one of the earliest that Monet did of the pond and its plant life. The style of the painting is realistic, as if he wanted to make a factual record. The slanting rays of the morning sun pick out the balustrade of the bridge, and the background trees and waterlilies are defined clearly, showing the pond as part of a garden setting; later, he tended to leave the trees and banks out of his paintings so that he could concentrate on the water and the waterlilies.

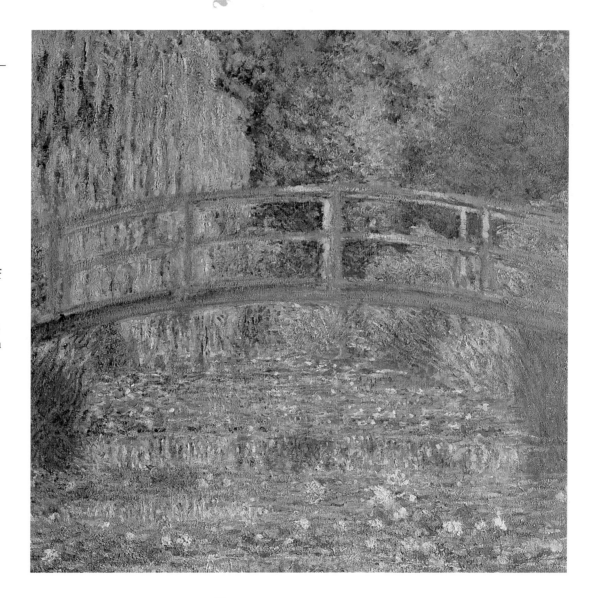

*Detail*

## THE ARTIST'S GARDEN AT GIVERNY

*1900  Oil on canvas*

Irises were one of Monet's favourite flowers and he planted a large bed of them at Giverny under flowering trees with nasturtiums and pansies along the borders. When the art dealer René Gimpel visited Monet to offer to become his agent he was greatly impressed by the little world the artist had created for himself. The garden 'resembles no other...it is not a meadow but a virgin forest of flowers,' Gimpel recalled.

Monet's skill and eye for subtle nuances of colour is very evident in this painting and the detail from it. In other, less sensitive, hands the blue and violet of the irises would not have the same vibrancy and variety.

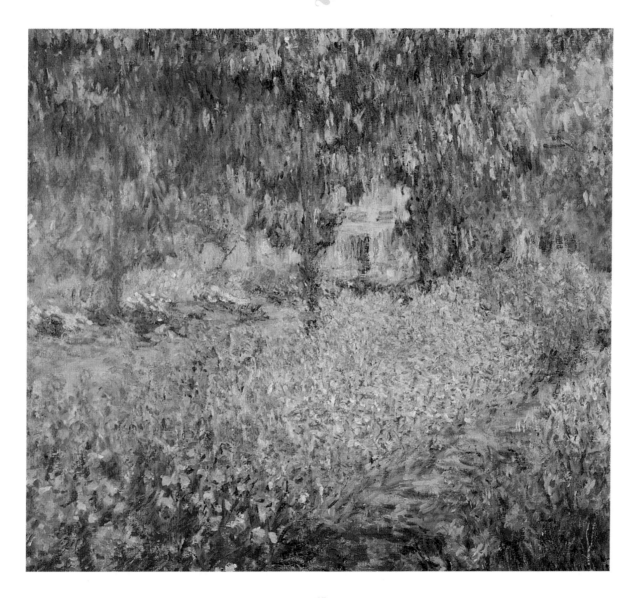

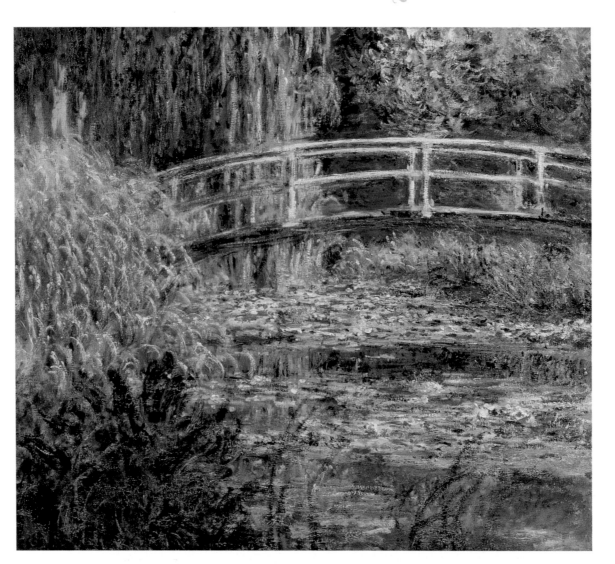

## WATERLILY POND: PINK HARMONY

*c.1900  Oil on canvas*

The changing light of day from dawn to dusk, seasonal alterations, the changing weather and other passing effects were all that Monet needed to see whole new landscapes in his water garden and lily pond. These changing conditions in the atmosphere were what he called the envelope in which human beings live, which he saw as a fundamental ingredient in the space/time universe. In this painting Monet seems to have been more aware than usual of the vegetation encroaching on the pond which included many varieties of trees such as elm, maple, poplar, tamarind, willow and Japanese cherry.

## A PATHWAY IN MONET'S GARDEN, GIVERNY

*1902  Oil on canvas*

Vivid orange and red nasturtiums border the sun-dappled pathway to Monet's house through a tunnel of trees and tall-growing plants. Along here, Monet could stroll and meditate on his day's work. Strolling up and down inside his cocoon of plants and flowers he visualized paintings in which colour was the subject and which, by its tonal subtleties, could reproduce the feeling of the scene whose precise description he was eliminating. At a time when art was moving towards a structural view of appearances he was against the trend.

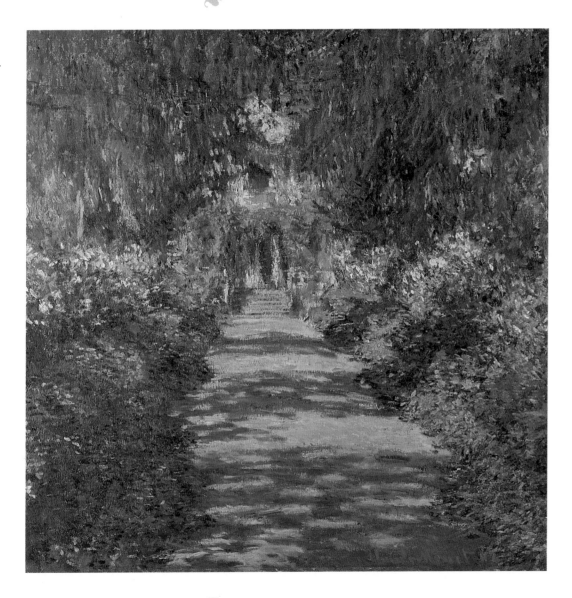

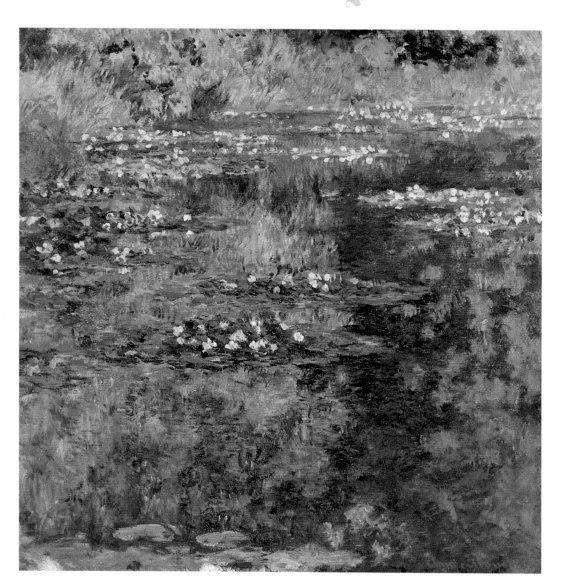

## POND WITH WATERLILIES

*1904  Oil on canvas*

Monet told a friend that he had not intended to concentrate his painting on the pond when he had first dug it out of the marshland he had bought near his house in 1893. By 1904, when he painted this picture, Monet had carried out extensive alterations on an additional plot of land, on which he enlarged the pond and planted a variety of trees.

## WATERLILIES

*1904  Oil on canvas*

This careful study of the waterlilies at Giverny foreshadows later works in which Monet excluded the banks of the pond and the sky. Monet's intention was to concentrate the whole painting into an area in which colour would say everything that he wanted to say but in this first view of the extended pond, which is painted realistically, he was no doubt getting the feel of his subject and creating a record of what the pond looked like at this stage in its development.

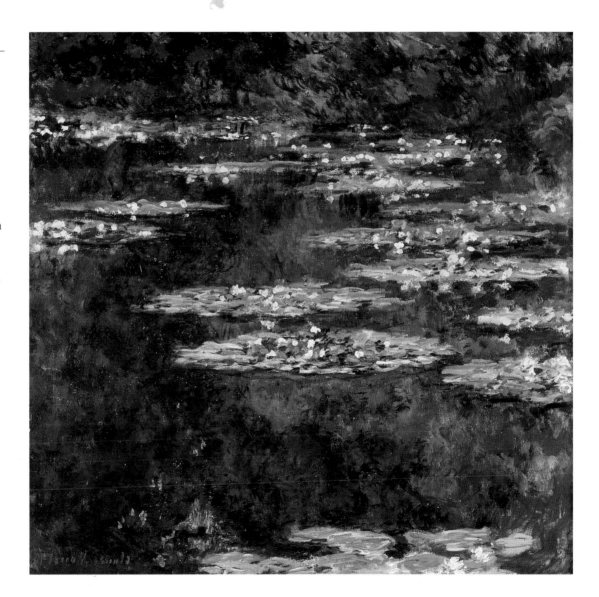

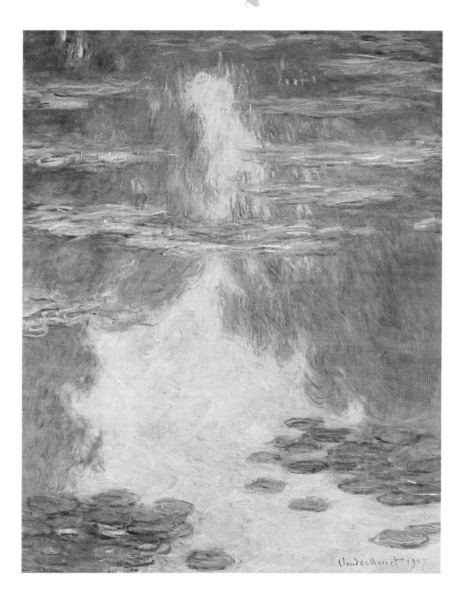

## WATERLILIES

*1907 Oil on canvas*

Monet's earlier series of paintings of haystacks, poplars and Rouen Cathedral had convinced him that subject matter was irrelevant to the aims he was pursuing. Nevertheless, he was positive that the feeling of his painting had to derive from a real scene. The work of the last period of his life is analogous with music in which a cohesive whole is made up of a balance of notes and phrases. The hours that Monet spent on his canvases were devoted to trying to find the perfect equilibrium between the areas of warm and cool colour in the predominantly warm ochre picture.

## NYMPHEAS (WATERLILIES)

*1908  Oil on canvas*

This is a delicately toned study of the reflections on Monet's pond. The very loose brushwork and the tree reflections show how Monet was coming to terms with the lightness of texture of the water and the surface reflection of the heavy foliage of the trees. Writing to his friend, the writer Gustave Geffroy, Monet said that these landscapes of water and reflections had become an obsession with him. 'It's quite beyond my powers at my age and yet I want to succeed in expressing what I feel.' Some forty-eight waterlily paintings from 1907-8 were exhibited in Paris in 1909 under a title suggested by Monet: *'Les Nymphéas, paysage d'eau'.*

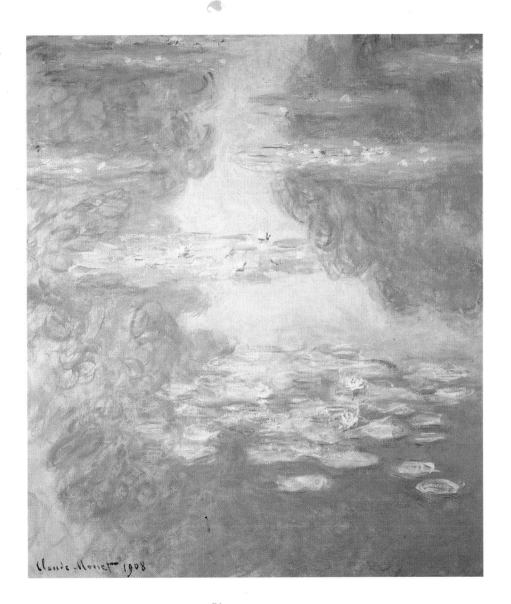

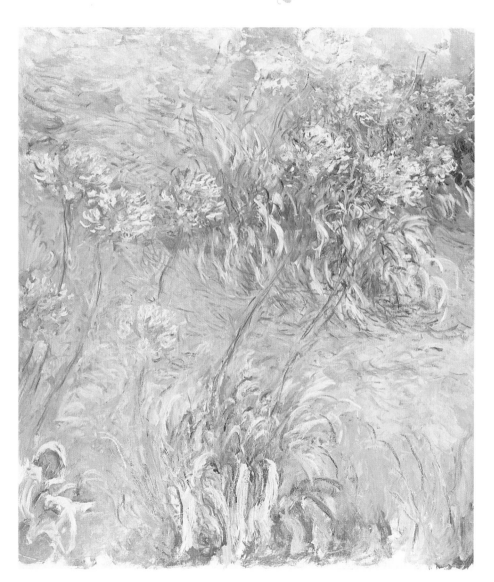

## IMPRESSION: FLOWERS

*c.1914-17 Oil*

Here is a very different treatment of flowers in which Monet has allowed the idea and feeling for his subject to dominate the picture rather than the drawing. The overall tone and fluid colour makes the picture filling the canvas and drawing in the viewer into a total mood and atmosphere much as is achieved by a piece of music. Monet was coming to the conclusion that colour was a language of its own which could be used to create a new form of expression.

## AGAPANTHUS

*1914-17  Oil*

This unfinished canvas provides an interesting insight into Monet's method of working. The drawing is barely suggested with fluid strokes of colour which allow a freedom in the development of the whole picture area. The main space, filled by the pond, gives a clue to the tonality of the picture as a whole; Monet's main concern has been to establish the value of the space with a rich mixture of warm colours which are contrasted with specks of colder greens and blues.

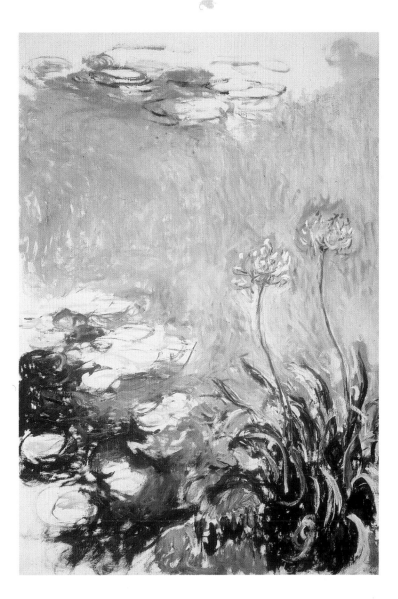

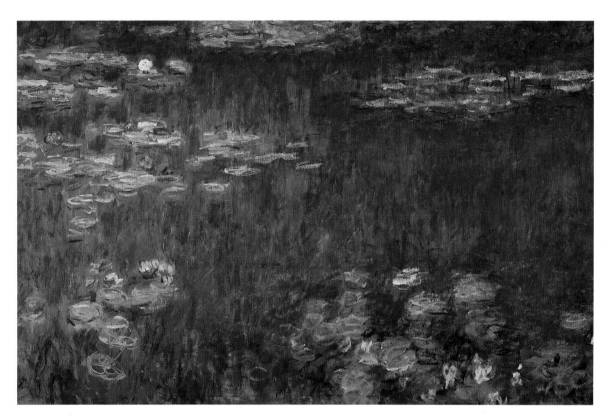

**WATERLILIES: GREEN REFLECTIONS** (Left section)

*1914-1918 Oil on canvas*

Monet had a large studio built at Giverny in 1916 to house the last great series of waterlily paintings, of which *Waterlilies: Green Reflections* was part. He spent years working on the paintings and was constantly re-working them; he was reluctant to part with them and it was not until the Great War was over in 1918 that he finally decided to let them go and to donate two others to the French state. It was prime minister Georges Clemenceau who had arranged for them to have a permanent home at the Orangerie in Paris.

In this painting Monet has created a mood very different from the one which dominates *Waterlilies: Morning with Weeping Willows* (pages 57-61). Here, the water has a dark brooding quality on which the lilies shine like distant stars. During the 1914-18 War Blanche Hoschedé had taken the family to a safe place but Monet obstinately refused to move. 'If these savages want to kill me,' he wrote to Gustave Geffroy, 'they will have to do it here under my paintings, before my life's work.'

**WATERLILIES: GREEN
REFLECTIONS**
(Central section)

*1914-1918  Oil on canvas*

There was nothing to distract Monet from his work during the war years, for he lived alone, except for servants, and received only his close friends. By now a painter with an international reputation, he was well off and lived comfortably. His only ambition now was to complete the great waterlilies series, but he was afraid that his failing sight might prevent it. This painting was one of the first to be completed.

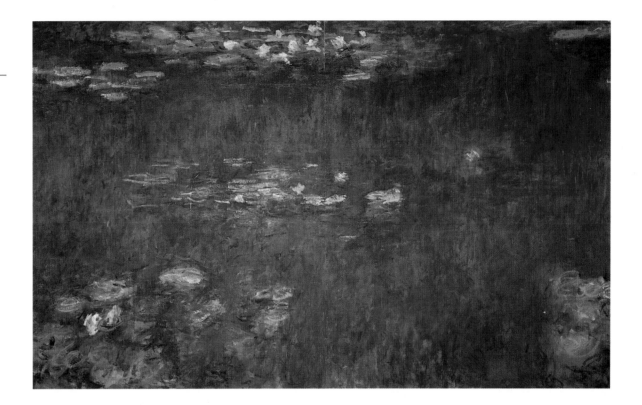

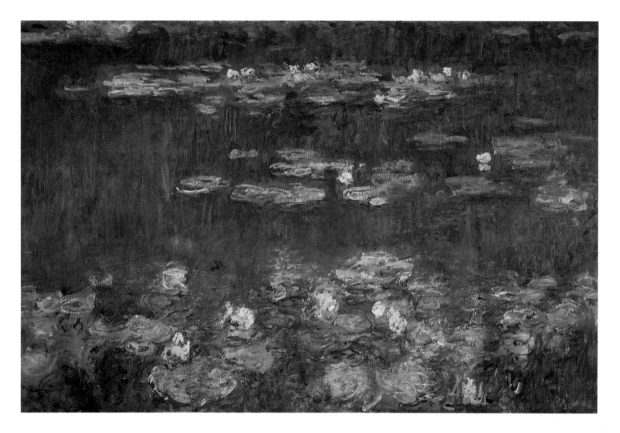

**WATERLILIES: GREEN REFLECTIONS** (Right section)

*1914-18  Oil on canvas*

The waterlilies on the surface of the dark waters are painted with confident freedom here. Monet's brush strokes have an enormous vitality — despite his complaints at the time that he was too old for such an undertaking. His enthusiasm and his essential optimism kept him painting despite the difficulties with his sight.

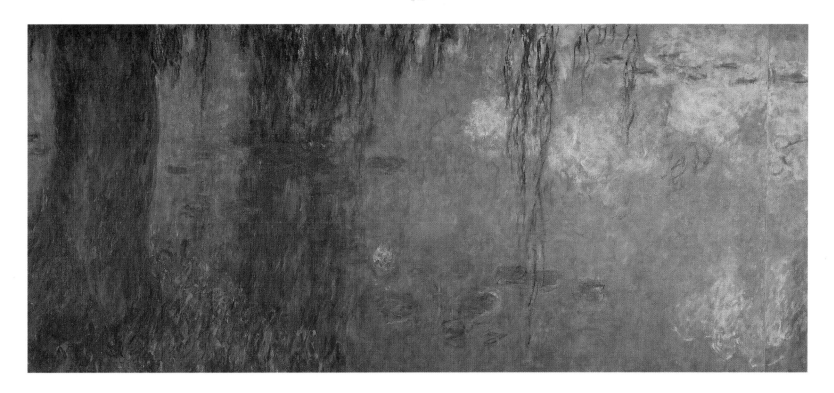

**WATERLILIES: MORNING WITH WEEPING WILLOWS**
(Left section)

*1916-26  Oil on canvas*

This great painting, with a total size of about two metres high by six metres long, was one of the first that Monet did in his last great series of nineteen waterlily studies. The waterlily paintings had begun as something akin to his series of Rouen cathedral, the poplars by the Epte and the haystacks at Giverny which he had done in the early 1890s, but grew into something much greater in concept. The idea was to fill a room with pictures of his pond so that the viewer would be completely enveloped by them. In this left-hand section Monet uses the willow trees which grew by his pond as a screen, much as he had used the tree foreground at Montgeron nearly forty years before. A foreground helped to create space between the viewer and the scene; later, Monet allowed an uninterrupted view.

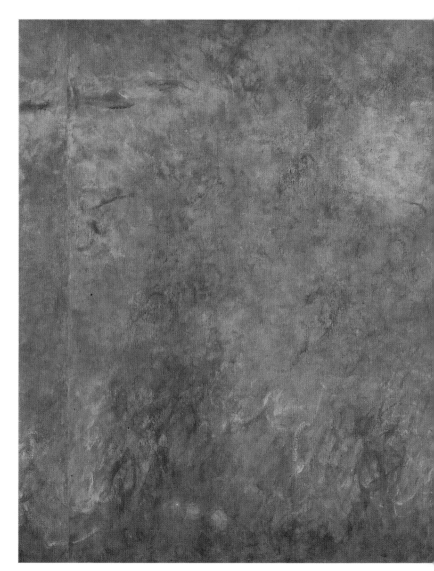

**WATERLILIES: MORNING WITH WEEPING WILLOWS**
(Central section)

*1916-26  Oil on canvas*

Floods in 1910 almost wrecked Monet's pond and would have interrupted for ever the ambitious painting project he was embarked upon. Moreover, he was also having trouble with his eyes and felt depressed about his ability to complete his work. 'Now more than ever,' he wrote to his friend Gustave Geffroy, 'I realise how illusory my undeserved success has been. No, I am not a great painter.' His mood passed, thanks to the encouragement of his fellow artists and friends, in particular Georges Clemenceau, who was to become Prime Minister of France in 1917, and who encouraged him to complete the project.

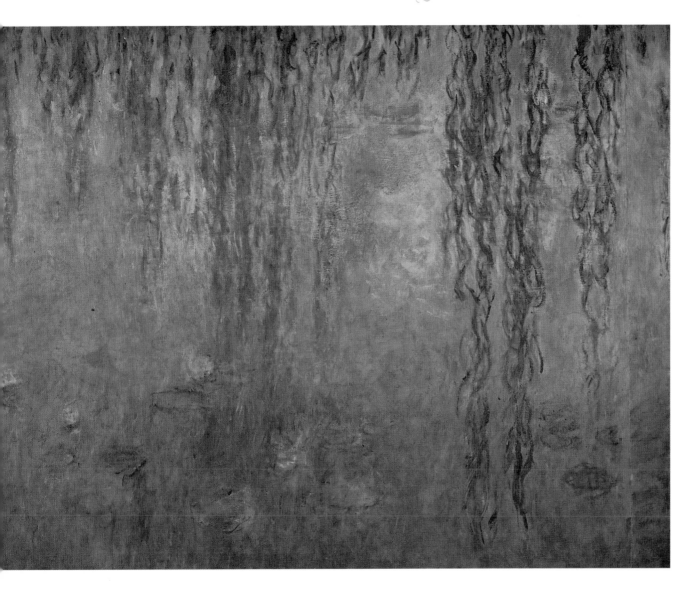

**WATERLILIES: MORNING WITH WEEPING WILLOWS**
(Right section)

*1916-26 Oil on canvas*

As the eye sweeps across the waterlily pond the vision of an infinite space is established in the viewer's mind. In this section Monet has also suggested the earth we live in by using the willow trees as a screen. In a way, Monet's late paintings have a religious feeling in a broad non-doctrinal sense. Monet's own feelings before nature and the universe were pantheistic. He was a nature worshipper and felt that in the mysterious and inexplicable ambiguity of so-called reality there lay a truth beyond words, but which we hoped to express in paint.

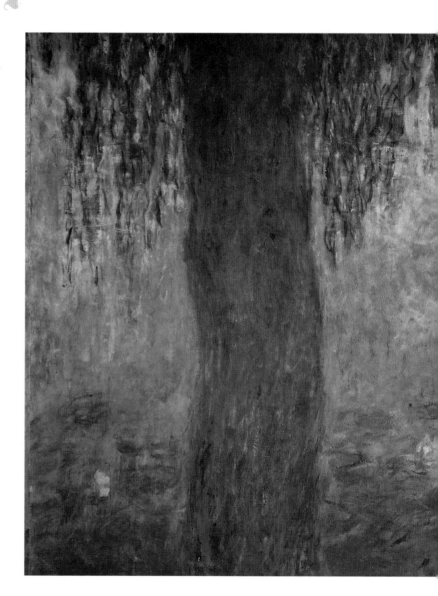

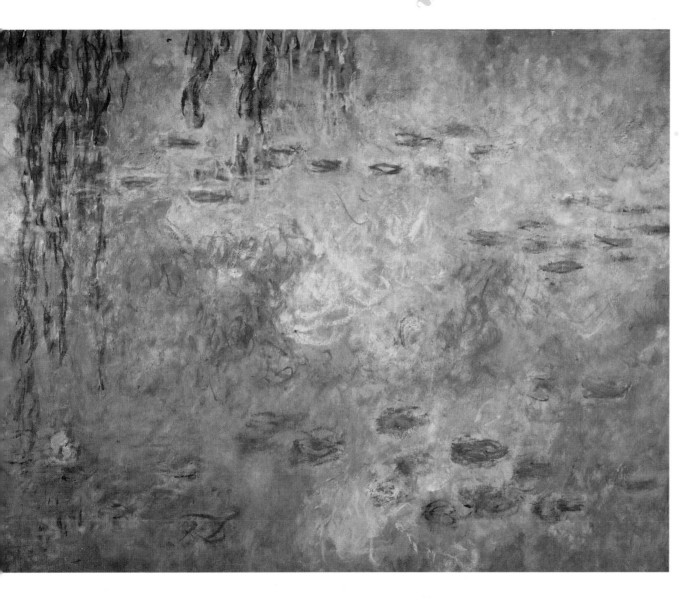

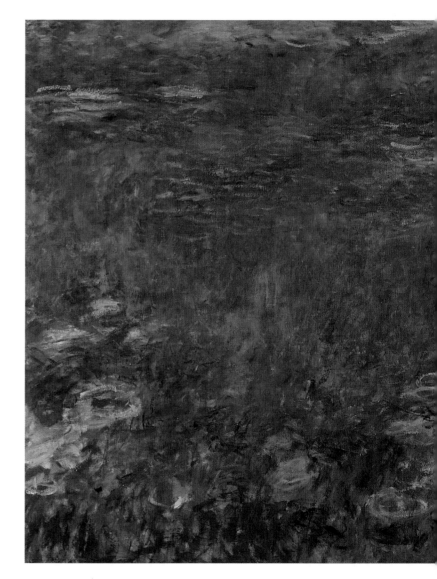

**WATERLILIES: THE CLOUDS** (Left side)

*1916-1926  Oil on canvas*

*Waterlilies: The Clouds* is another of the great series of waterlily paintings which Monet bequeathed to the French state and which are now in the Orangerie in Paris. The dream of having an entire gallery in France's capital devoted to his waterlily paintings had enthused Monet, despite his misgivings about undertaking such a tour de force at his age. Clemenceau, who was not known as 'Tiger' for nothing, was determined that Monet should take on the gigantic task. No doubt there was an element of national pride at work in the heart of the patriotic politician who steered France safely through the last years of the war and saved the waterlilies.

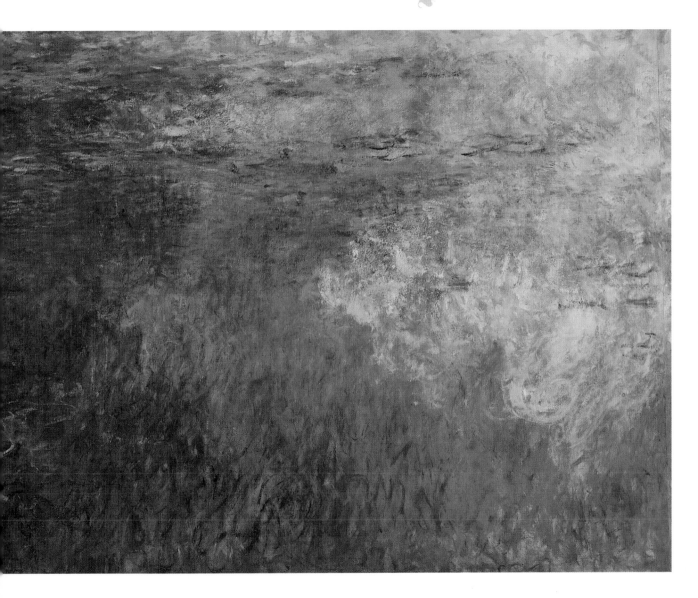

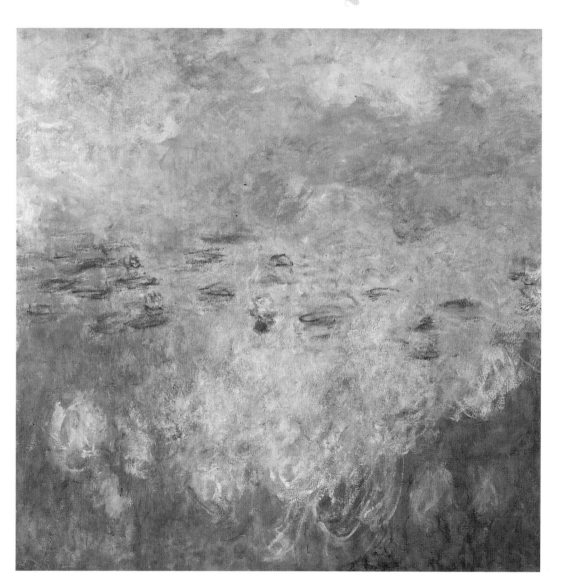

## WATERLILIES: THE CLOUDS
(Central section)

*1916-26  Oil on canvas*

The centre section of this three-panel painting shows the cumulus clouds reflected in the water of the lily pond. There is an almost total concentration on the reflection and hardly any part of the opposite bank of the pond to be seen. This was a characteristic of all the large panels that Monet painted and which he kept in his studio on specially built easels so that he could push the vast canvases about as he painted and retouched them over a ten-year period.

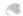

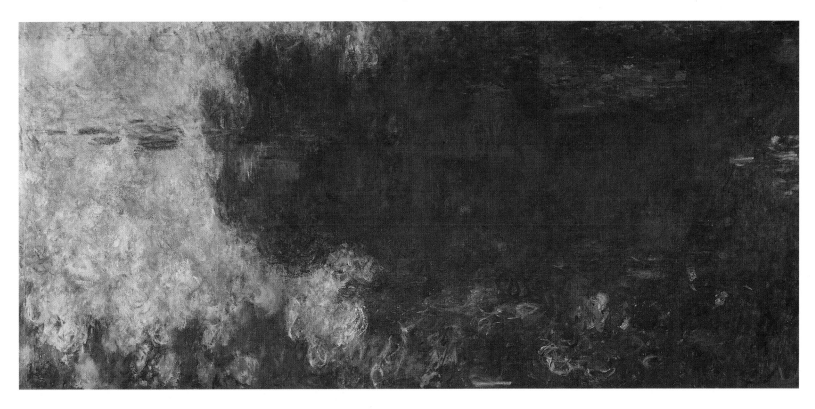

**WATERLILIES: THE CLOUDS**
(Right side)

*1916-26  Oil on canvas*

There is a great deal of ambiguity of the reality that inspires the right-hand side of this painting, as if Monet has launched himself off the edge of a cloud into space itself. Here he floats weightlessly in a world of pure colour in which tone and density suggest mysterious depths of space and arouse strong but unidentified emotions in the viewer. Like all Monet's later work, this is a painting to be looked at with a patient and tranquil mind, when it induces the peace and harmony that accompanies meditation.

**WATERLILIES: MORNING** (Left section)

*1916-26  Oil on canvas*

This is the largest of Monet's composite paintings of waterlilies, and was done in four sections. Its title, 'Morning' suggests that Monet painted it from life, as had always been his habit, though when he was completing his great final works Monet did most of the painting in his studio. George Clemenceau's original arrangement for the paintings was that they should be housed at the Rodin Museum but this had been unsatisfactory so the Jeu de Paume in the Tuileries Gardens was suggested. Finally, they were housed in special rooms built at the Musée de l'Orangerie, where they are one of the great artistic highlights of Paris.

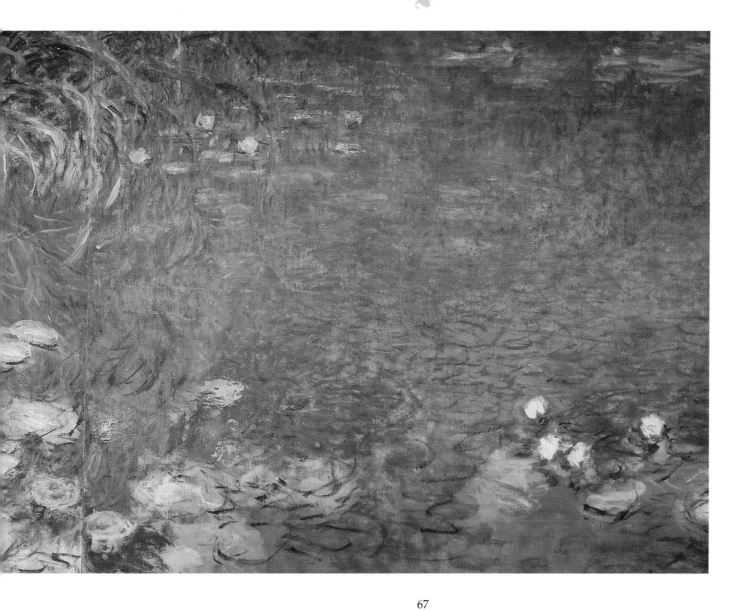

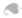

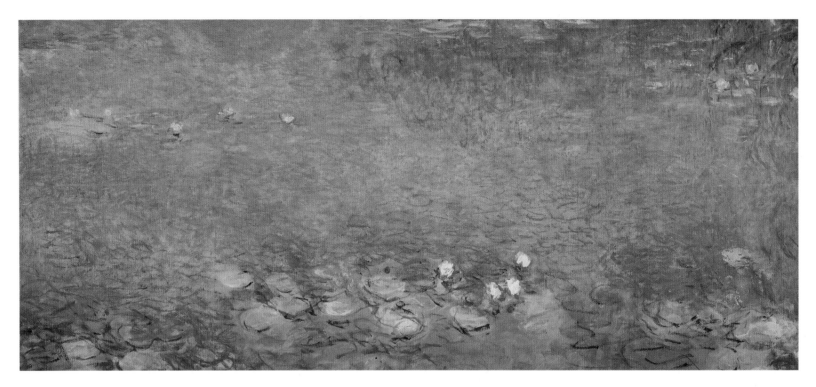

**WATERLILIES: MORNING**
**(Centre left section)**

*1916-26  Oil on canvas*

The centre left panel of this large painting is almost devoid of features; a few waterlilies float in a vast empty space of violet blue, suggesting an infinity of unknown and mysterious space. In this final vision of Monet's mind there is a link to the contemplative religions of the east and the philosophy of Lao Tse who saw truth in forms without contours and open-ended meditation. Not everyone could understand what Monet was attempting and as late as 1931 the critic Benois was exclaiming 'L'ensemble produit une impression de catastrophe'. He would have preferred Monet to stick to the style of his earlier paintings with their more conventional descriptive approach.

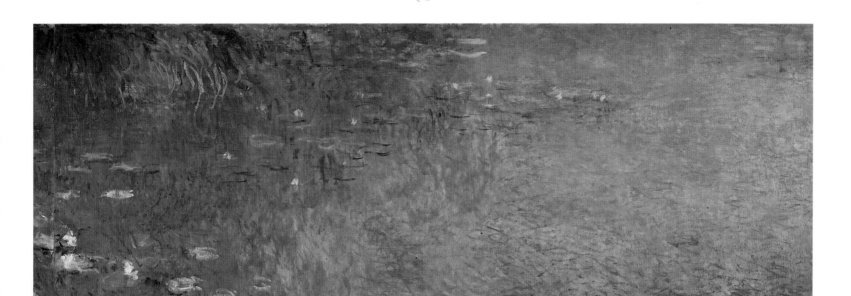

**WATERLILIES: MORNING**
(Centre right section)

*1916-26 Oil on canvas*

The centre right panel of this panoramic painting is a continuation of the others but also essential to the whole concept for it adds scale to the view and provides more space for the subtle interplay of colours with which Monet is encouraging the viewer to meditate on existence. Both Clemenceau and Geffroy were united in opposition to the idea that Monet was simply making his art more abstract and agreed with the painter that his work, though lacking in tangible features, was firmly evolved from nature, which was the inspiration for every subtle colour and tone.

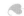

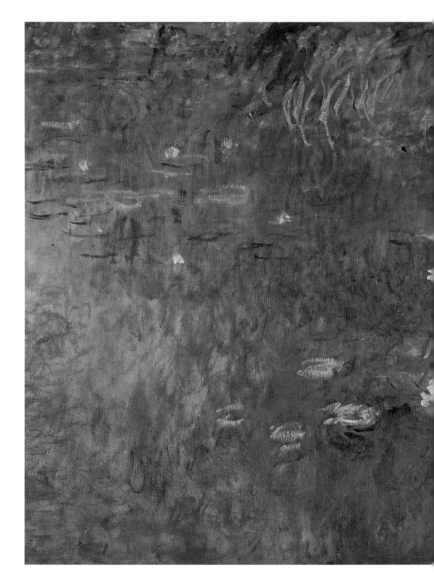

**WATERLILIES: MORNING** (Right section)

*1916-26  Oil on canvas*

Monet's wife Alice died as he was beginning his final series of paintings of his garden and pond and having depended on her for so long he was distraught. He wrote to Clemenceau to say that he found it difficult to work and that he spent much time consoling himself by re-reading the long correspondence that he and Alice had carried on during the years that he was travelling in search of new and saleable subjects. Eventually, however, with Clemenceau's encouragement he returned to work on his giant canvases.

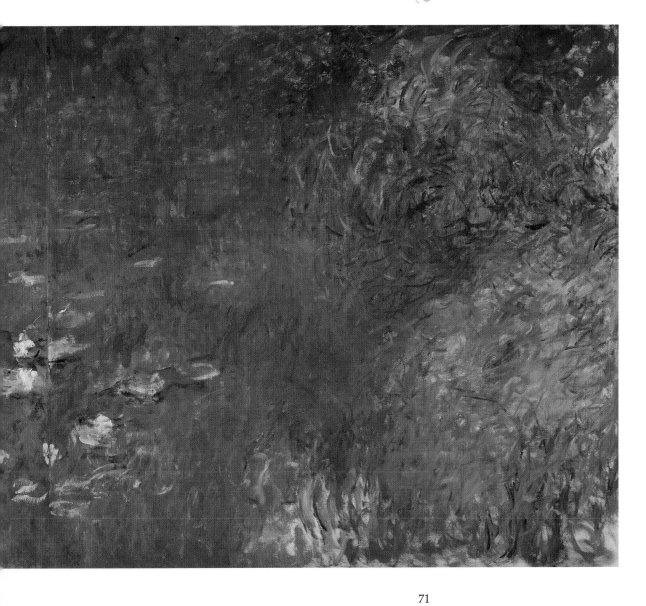

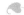

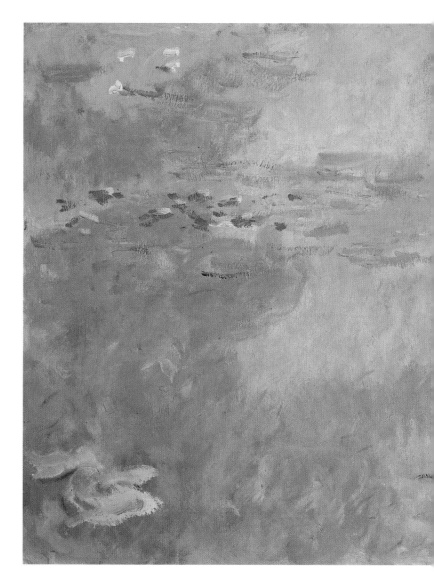

## WATERLILIES AT GIVERNY

*1917  Oil on canvas*

The year 1917 was not a happy one for Monet. His old friend Degas died and his funeral was a sad occasion for Monet. It was also the year of the Battle of Passchendaele and since his son Michel was at the front Monet must have had many anxious hours.

Despite these worries, Monet was able to continue working with a serenity that is evident in this painting of waterlilies, whose violet and ochre colour scheme gives it a timeless and dreamlike quality which disguises the artist's anxious thoughts.

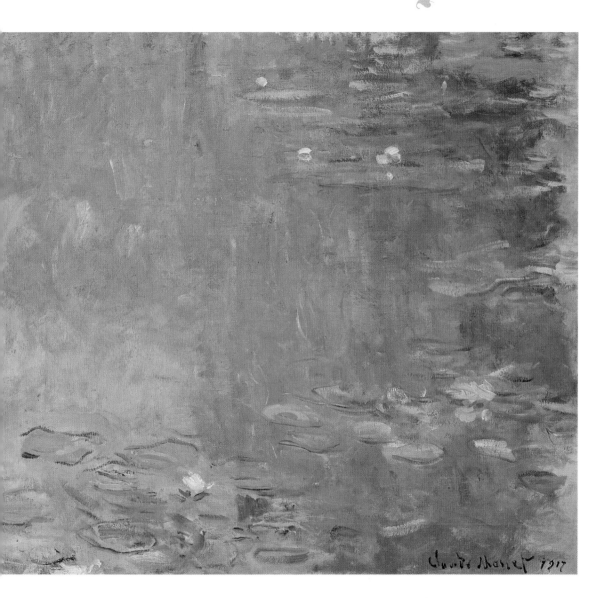

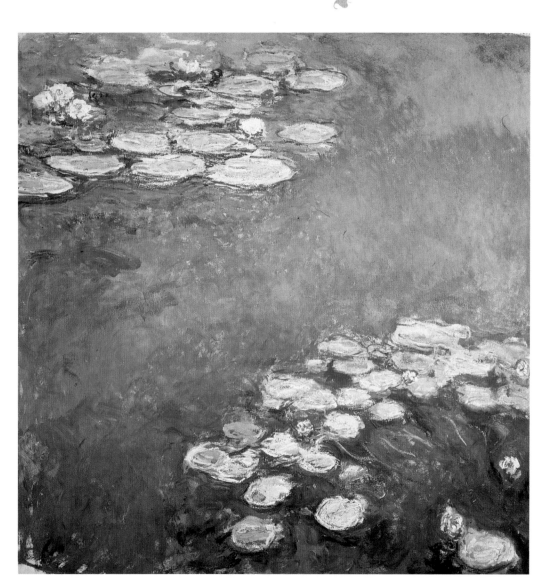

## NYMPHEAS

*1918-19 Oil on canvas*

The French word 'nymphéa' is a much more evocative one than 'waterlily', conjuring up images of classical mythology. Although a pantheist at heart, Monet was not particularly interested in painting the epic pictures of gods and goddesses that appeared so regularly in the Paris Salon before the Impressionists came along, but he did reflect the ancient philosophies through his love of nature. His own character was that of Rousseau's ' natural man' with an earthy delight in food, drink and other sensuous pleasures.

## WATERLILY POND: THE BRIDGE

*1918-24  Oil on canvas*

Monet painted most of his paintings of the Japanese bridge over his waterlily pond at the turn of the century when he was first enjoying the garden and pond which he had created. The bridge was a new construction then and did not yet have the wisteria which later grew over it. At the end of his life Monet returned to painting the bridge with the new loose strokes which his sight problem had obliged him to adopt.

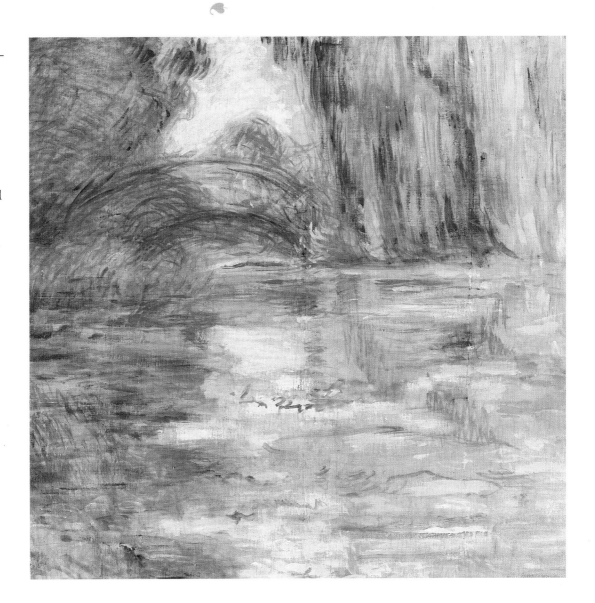

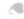

### IRISES BY A POND

*1920  Oil on canvas*

This close-up of a clump of irises by the edge of his pond was painted with the long brush strokes that Monet adopted when he was having trouble with his eyes. At the insistence of Dr Clemenceau and other friends Monet went to see an eye specialist who gave him eyedrops which appeared to improve his sight temporarily, though Monet complained of distortion of the colours. The variety of colours and brushwork show that despite his problems Monet had not lost that sensitivity to colour which made Cézanne exclaim that Monet was 'just an Eye, but what an eye!'.

## GARDEN OF GIVERNY

*1923  Oil on canvas*

The year 1923 was crucial for Monet. His sight had become so bad that he had to agree to an operation. He signed a declaration by which nineteen waterlily paintings would go to the Institut des Beaux Arts to be hung at the Orangerie and added two more as a gift to the French nation. In this, one of the last general pictures of his garden at Giverny, done in the loose style he had adopted when his sight was failing, he showed the path round the pond, a view which no doubt reminded him of the numerous times he had walked along it.

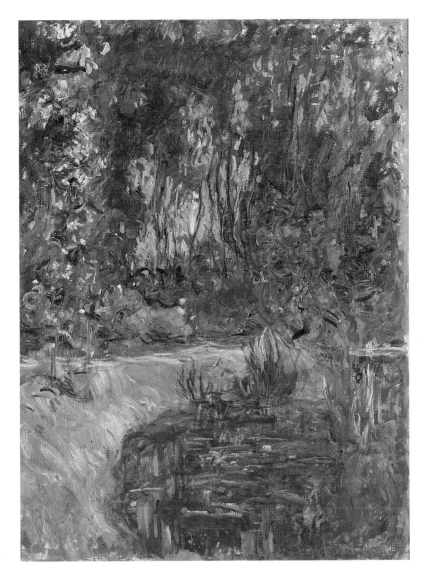

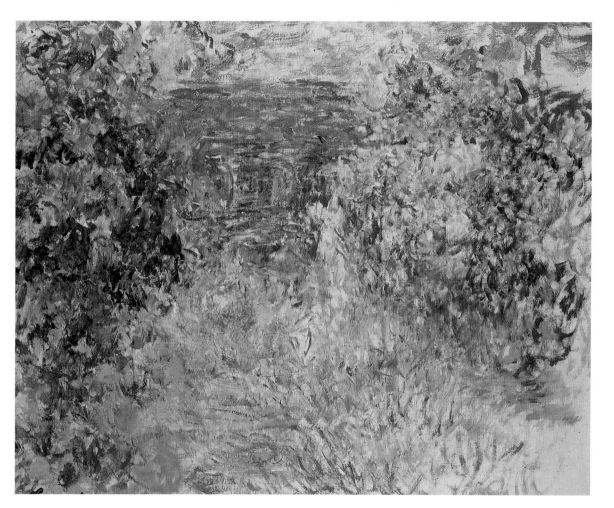

## THE GARDEN AT GIVERNY

*1924 Oil on canvas*

Although Monet gave much attention to the pond at Giverny he was also a keen gardener. With the enthusiastic help at first of Alice Hoschedé and later, when he grew wealthy, of a head gardener and six under gardeners to whom he gave detailed instructions, he planted round the house at Giverny huge beds of long-stemmed flowers which would give him something to paint all year round. There were poppies, irises, tulips and other flowers in spring and peonies, sunflowers and asters in established borders which kept going throughout the summer. In this painting Monet has painted the large rose bushes which grew abundantly in the tall grass.

## WATERLILIES: THE JAPANESE BRIDGE

*c.1923  Oil on canvas*

In July 1925 Monet wrote to his eye specialist to say, 'I've truly recovered my sight at last and did so virtually at one stroke.' He also wrote a letter to another friend to say 'You know perhaps that at last I have recovered my true sight. This is for me a second youth. I have returned to work'. But was Monet being too optimistic? His last painting of his beloved bridge suggests that his problems were not over. He died just 18 months after he wrote that optimistic letter, on 5 December 1926. The studio and garden were kept up by his loving stepdaughter Blanche, who had married his elder son, Jean. After Blanche Hoschedé-Monet died in 1947 they were both neglected. In 1966 a generous donation from the United States of America enabled the whole property to be completely restored after Michel Monet had given it to the nation and a new life began for Claude Monet's beautiful and evocative gardens at Giverny.

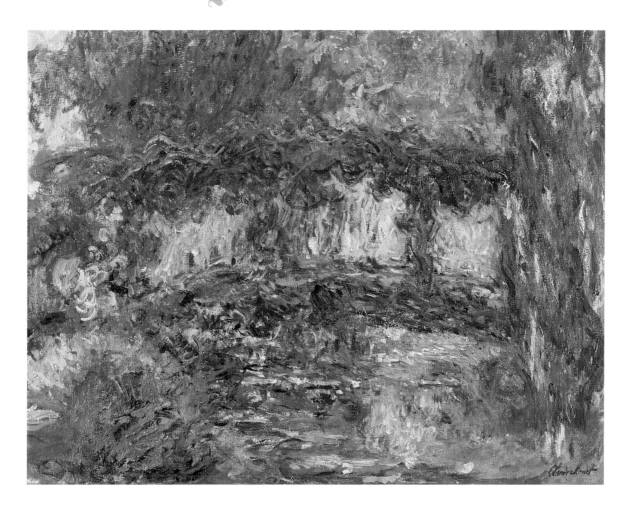

## ACKNOWLEDGEMENTS

*(Figures in brackets denote page numbers.)*

The Publisher would like to thank the following for their kind permission to reproduce the paintings in this book.

*The Bridgeman Art Library, London,* for supplying transparencies from the following collections:

*Art Institute of Chicago* (76)

*Bayerische Staatsgemaldesammlungen, Munich* (5 right)

*Christie's, London* (26, 33, 34, 51, 78)

*Courtauld Institute Galleries, University of London* (36)

*Fine Arts Museum of San Francisco, California* (37)

*Fitzwilliam Museum, University of Cambridge* (40)

*Galerie Beyeler, Basle* (74)

*Giraudon/Cleveland Museum of Art, Ohio* (20)

*Giraudon/Musée des Beaux-Arts, Caen* (48)

*Giraudon/Musée des Beaux-Arts, Le Havre* (49)

*Giraudon/Musée des Beaux-Arts, Lyon* (35)

*Giraudon/Musée des Beaux-Arts, Nantes* (72)

*Giraudon/Musée d'Orsay, Paris* (14, 23, 25)

*Giraudon/Private Collection* (15)

*Hermitage, St Petersburg* (18, 27, 28)

*Lauros-Giraudon/Musée d'Orsay, Paris* (5 left,19, 24, 29, 45, 46)

*Lauros-Giraudon/National Gallery of Art, Washington* DC (31)

*Lauros-Giraudon/Musée des Beaux-Arts, Rouen* (Front Cover, 38)

*Metropolitan Museum of Art, New York* (21, 32)

*Minneapolis Institute of Arts, Minnesota* (79)

*Musée de Grenoble* (77)

*Musée de l'Orangerie, Paris* (54, 55, 56, 57, 58, 60, 62, 64, 65, 66, 68, 69, 70)

*Musée d'Orsay, Paris* (4, 16, 19, 43)

*Musée Marmottan, Paris* (53)

*Museum Boymans van Beuningen, Rotterdam* (17)

*Museum of Art, Rhode Island School of Design, USA* (22)

*Museum of Fine Art, Boston, Mass.* (39)

*Museum of Fine Arts, Budapest* (30)

*National Gallery, London* (42)

*Österreichische Galerie, Vienna* (47)

*Private Collections* (50, 52, 75)

*Pushkin Museum, Moscow* (13, 41)